IMAGES
of America

HANOVER COUNTY

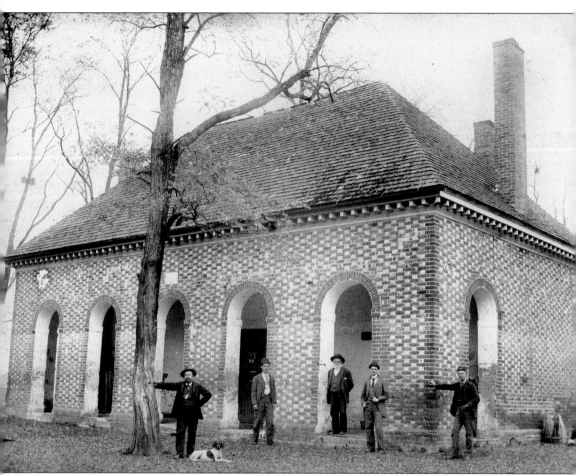

HANOVER COURTHOUSE. Hanover Courthouse was built in 1735 to provide a convenient location for local residents to conduct official business. Built in the elegant minimalist style of Colonial architecture of the period, it is a replica of the King William Court House. Many of the imported bricks have the sheen of salt glazing that turns them a shimmering blue. The brickwork is Flemish bond. It was here that irate Hanoverians urged a young Patrick Henry to argue against the crown in the famous "Parson's Cause" case in 1763. The Revolutionary War saw Cornwallis and Tarleton gathering their troops before marching to Yorktown and surrender. During the Civil War, Grant passed the green during his Overland Campaign. (Hanover Tavern Foundation.)

IMAGES
of America

HANOVER
COUNTY

Dale Paige Talley

ARCADIA

First published 2004
Reprinted 2005

Published by Arcadia Publishing
Charleston SC, Chicago IL, Portsmouth NH, San Francisco CA

Printed in Great Britain

Library of Congress Catalog Card Number: 2004108734

For all general information contact Arcadia Publishing at:
Telephone 843-853-2070
Fax 843-853-0044
E-mail sales@arcadiapublishing.com
For customer service and orders:
Toll-Free 1-888-313-2665

Visit us on the internet at http://www.arcadiapublishing.com

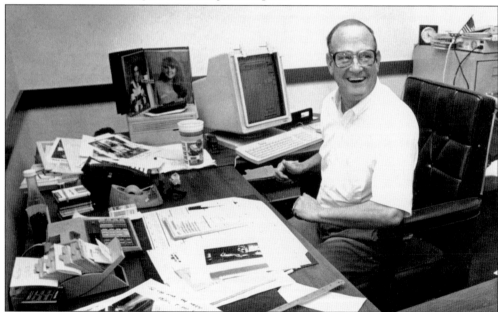

JAY MALCOLM PACE. It's impossible to tell the story of Hanover County's history without remembering J. Malcolm "Jay" Pace III. As editor and publisher of Hanover's community newspaper, the *Herald-Progress*, Pace was a shining star in the center of the universe. He took great pride in Hanover and considered the community his family. In addition to his roles as editor and publisher of the local paper of record, Pace always made time to wear the many hats the people of Hanover threw at him. From Uncle Sam in the Ashland Fourth of July parade to musical director of the Ashland Variety Show, Pace was an integral part of the county he cherished. Pace left his beloved community behind April 12, 2004, when he died unexpectedly at the age of 58 after a brief illness. (*Herald-Progress.*)

CONTENTS

ACKNOWLEDGMENTS

The Herald-Progress has been the voice of Hanover County for nearly 100 years. Its archival photographs and careful documentation of the county's history provided the bulk of the material for this work. Everyone there was enormously supportive. Thanks to Jay, Pat, Steve, and Naomi Pace; Ann Peters; Ann Ruane; and Mary Franke Miller for their efforts and enthusiasm for the project.

Judy Lowry of the Florence Page Memorial Library of History and Genealogy often interrupted her work to help. Judy Showalter made the Randolph-Macon archives accessible. I want to thank Jenny Dibas of the Hanover Tavern Foundation for her time and helpful suggestions. Don Makowsky and Carolyn Hemphill worked diligently to supply material from the Hanover County Black Heritage Society. Doug Goodman of the Hanover County Sheriff's Department and Billy Martin, formerly of the Ashland Police Department, gave freely of their time. Ron Bonis of the Virginia Commonwealth University Library was extremely prompt and helpful. Dementi Studios allowed access to their astonishing collection of historical photographs. Dr. Robert Bluford cleared up some details about the contributions of Samuel Davies to religious reform in Hanover County.

I especially want to thank the following for lending materials from their personal collections: Susan and Woody Tucker; Tom Willis; Art and Dale Taylor; Rick Gran; Alan K. Smith; Wesley Smith; Caroline Cherry; Sandra Talley; Paul Vidal (who corresponded from France); Ron Luck; Dorothy Jones and her assistant, Esther Zicafoose; Barbara Jones; Edith Sagle Jones; Anne Curtis Palmore; and Anne Nelson, whose knowledge of the county and its history was invaluable. Shawna Hurn supplied drawings so we could imagine King George.

I want to thank Frances Watson Clark, with whom I share the love of many things, including, apparently, endless hours of sorting photographs. It was she who suggested I do this work.

My sisters, Anne Regan, Pamela Stoneburner, and Diane Talley, deserve crowns for being dedicated mothers and teachers. Nancy Wiener has helped me to see the real power that women have for 35 years. Jim Talley keeps me laughing.

Finally, it is my husband, John Fink, who never complains when I interrupt his train of thought by reading aloud, always starting with "Hey . . . listen to this!" He brought it on himself, however, by allowing me to retire to do projects like this. If there were more people like him, the world would be a better place, I promise.

INTRODUCTION

When a friend of mine suggested I put together this visual history of Hanover County, I quickly asserted that I am no historian. As we pored over the images, we found ourselves so charmed by remembrance of things past that we realized others might be equally attracted to this incomplete excursion into history. I hope these images will inspire those who see them to look deeper into the history of this corner of the world.

When the first English adventurers, led by Capt. John Smith, sailed up the York River to the Pamunkey around 1612, they encountered prosperous, if not entirely harmonious, Algonquian, Iroquoian, and Siouan–speaking natives who had been here for more than 11,000 years. Culture shock and a relentless wave of white settlers soon overwhelmed the natives. We have only the melodious names like Totopotomoi and Mechumps, for whom branches of the Chickahominy and Pamunkey are named, to remember. Both men had been loyal to the English and died fighting in wars against Chief Powhatan.

After the excruciating first settlements at Jamestown, the English came in waves. In the 1640s, when Civil War in England stripped those loyal to King Charles—the Cavaliers—of their land and prestige, they came to Virginia to replicate a life and government imperiled in their own country. They came to reassert the Church of England and its laws and to rebuild lost fortunes. Liberal land grants and headright laws allowed the earliest settlers to acquire vast tracts of land. Venture capital to build plantations came from English stockholders in the Virginia Company of London. Expatriate landowners oversaw huge plantations; indentured servants and blacks from Africa provided the muscle. A thriving tobacco economy was born. However, reliance on slave labor and English markets would bring issues no one could have foreseen in 1640. It is ironic that a society originally bent on the preservation of English law, custom, and trade would evolve to overthrow it

Around 1654, between the Pamunkey and Chickahominy Rivers, New Kent County was established. The northern border was the North Anna River. To the south, the county ended at the Chickahominy. The western border was not established, as no one truly knew what lay beyond the unexplored Blue Ridge Mountains. Early government was run by the Church of England through the establishment of ecclesiastical units of government, or parishes. St. Peter's Parish had encompassed all of what is today New Kent County. By 1704, the Church split the territory into two parishes, the easternmost called St. Peter's and the rest St. Paul's. It was along those lines that Hanover County was established in 1720. The northern and southern borders remained the same with the western border still undefined

Travel within Virginia in those days was on rivers. Roads were practically non-existent. Large warehouses sprang up along the Pamunkey with access to plantations and ships bound for England. Newcastle and Hanovertown were established along what is today River Road close to Old Church. Hanovertown was the largest tobacco port in the New World in the mid-1600s. It missed becoming the state capital twice by a slim margin, but revolution and the river's own ecology brought about the demise of the nascent towns.

In pre-Revolutionary America, church and state were not separate entities. Religious reform enlivened by evangelical Methodists like George Whitfield incited reading houses to organize to consider a new church order. In 1747, Samuel Davies, a Presbyterian, was licensed to preach in Virginia. He came to Hanover County as the first non-Anglican preacher in Virginia, and he argued for the education of slaves. It is said that the classic spiritual "Lord, I Want to Be a Christian in My Heart" was written by Davies and sung at Polegreen Church, the home of his ministry until 1752. Patrick Henry is said to have credited Davies with "teaching me what an

orator should be." It is through the effort of Davies and others, and the forward thinking citizens of Hanover, that the struggle for religious freedom in America was begun. According to Dr. Robert Bluford, "The first legislative body in the world to adopt a statute of religious liberty was Virginia in 1786."

After the Revolution, Hanover experienced a time of prosperity. Many of the elegant mansions that dot the countryside were established during the period from 1790 to 1860. Hanover remained largely rural and struggled to develop an economy based not on tobacco but on the cultivation and milling of grains and the development of a timber industry. By the 1840s, the railroad was growing all over the world. In Central Virginia, the Richmond, Fredericksburg and Potomac Railroad envisioned laying track and carrying passengers from Richmond to Aquia Creek, where they could board company-owned steamships to travel to Washington. In 1845, Slash Cottage was built to provide a stopover point for travelers. Complete with mineral spring, ballroom, bowling alley, racetrack, billiard room, and other outstanding amenities, Slash Cottage was, by the 1860s, a thriving resort renamed Ashland after native son Henry Clay's home in Kentucky. Ashland was here to stay. After the Civil War, Randolph-Macon College relocated from Mecklenburg County when inducements from the railroad made them an offer they couldn't refuse.

The Civil War was devastating to Hanover County. Just 12 miles north of the capital of the Confederacy and on a straight line from Washington, it lay between the Federal armies and the prize of prizes—Richmond. It can be fairly said that Hanover County suffered some of the worst fighting, occupation, and privations of the subsequent depression than any area in the country during that conflict. Many families not only lost their fathers, sons, and brothers, but their land and their ability to make a living—some forever.

By the turn of the century, however, the development of Ashland and Randolph-Macon College encouraged growth in the central region of the county. The eastern portion, or Lower Hanover, with its amazingly fertile soil, produced high quality produce for markets from Washington to Richmond. Upper Hanover concentrated on timber mills and sun-cured tobacco. Throughout the county, dairies, poultry farms, and horse farms continued to prosper.

No representation of Hanover County is complete without a discussion of such emblems as Patrick Henry, Henry Clay, Dolley Madison, Samuel Davies, and Edmund Ruffin. Yet less well-known individuals and families who put their heads down and their shoulders to the wheel and moved ahead have nurtured so much of the county's backbone and spirit. These are the people celebrated here. I only wish I could have included all of them.

KING GEORGE I OF ENGLAND. Hanover County was officially carved from New Kent County in November 1720 when Gov. Alexander Spottswood agreed to a proposed act of the House of Burgesses. Still a British colony, the county was named after the reigning king of England, George I, from the royal court of Hanover, a German province. (Drawing by Shawna Hurn.)

One
EARLY EMBLEMS

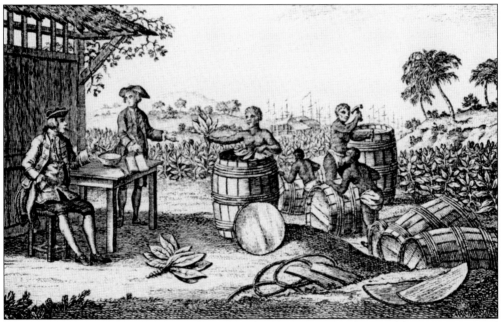

BUILDING PLANTATIONS. Many early Colonial enterprises were financed by venture capital from the Virginia Company of London. When it became apparent to colonists that they would not be able to meet demands to produce silk, iron, and glass, they turned to tobacco. The growth and exportation of tobacco became the prime focus of Hanover County and the reason to build plantations along the banks of the Pamunkey. The production of tobacco required a large labor force. By 1705, landowners passed laws to control the labor they needed to run the colony by establishing a systematic "slave code." Stated simply, the code provided that "all servants imported and brought into this country, by sea or land, who were not Christians in their native country . . . shall be . . . slaves, and as such be here bought and sold notwithstanding a conversion to Christianity afterwards."

TOBACCO AS CASH CROP. Learning to make a profit from tobacco, the cash crop in Virginia in the 1600s, became the challenge of the Virginia Company of London. Setting up the "headright system" of land acquisition, the company gave 100 acres to anyone who established seven years' residence. To those with stock in the company, the crown offered 100 acres per share. Finally, to anyone who either paid his own passage or that of another to Virginia, 50 acres were granted. The system allowed land ownership across a wide spectrum of emigrant society.

EARLY AMERICAN CURRENCY. There were two forms of currency—the English pound and tobacco. One pound in weight of tobacco equaled one penny of English money. By 1730, licensed tobacco inspectors operated under special Acts of the Assembly to issue certificates to growers for tobacco inspected and stored in the warehouses. In effect, the warehouses were the colony's first banks. To understand the buying power of tobacco, here are some prices of goods and services: a one-way trip across the Atlantic cost 750 pounds of tobacco; a day's labor, 20 to 30 pounds; a bushel of beans, 40; a bushel of corn, 125; and a pair of stockings, 50.

NEWCASTLE AND HANOVERTOWN. The town of Newcastle was mapped in 1736. At the site of Page's Warehouse along today's River Road in Central Hanover, Hanovertown was established around 1761. The warehouse and town became the largest tobacco port in the New World at that time, shipping about 1,600 hogsheads of tobacco (weighting 1,000 pounds each) annually to England. Tobacco had little intrinsic value in Virginia. By the end of the Revolutionary War, the warehouses had been burned, and trade with England had lost its momentum. The Pamunkey River had begun to silt, making navigation difficult. Waterways and canals were constructed closer to Richmond on the James, and the once-booming towns simply died from neglect. (Dale Talley.)

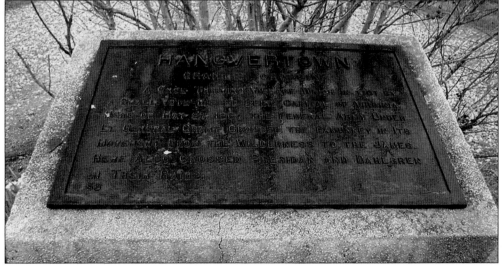

HANOVERTOWN MARKER. Today, nothing remains of Hanovertown but a bronze marker. In the curious shorthand reserved for plaques, it reads: "A once thriving village which in 1761 by a small vote missed being the Capital of Virginia. Here on May 27, 1864, the Federal Army under Lt. General Grant crossed the Pamunkey in its movement from the Wilderness to the James. Here also crossed Sheridan and Dahlgren on their raids." (Dale Talley.)

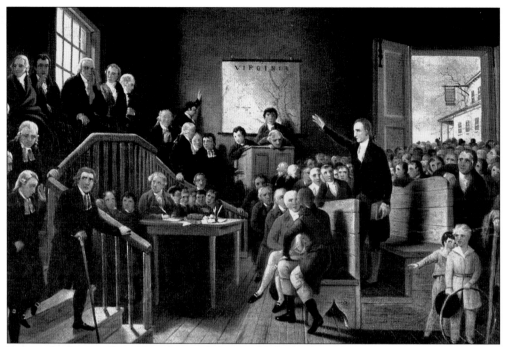

PARSON'S CAUSE. In 1758, clergy of the Established Church were paid in tobacco. Short markets that year sent tobacco soaring to 6¢ per pound. Fearing financial crisis, the community passed an ordinance allowing debts payable in tobacco to be paid in currency at 2¢ per pound. An enraged clergy sued and lost when Patrick Henry pleaded at Hanover Courthouse: "This cause means more to all of us in the Colony than the question of a Clergyman's pay. . . . It touches our religious and our political freedom." (Painting attributed to George Cooke c. 1830.)

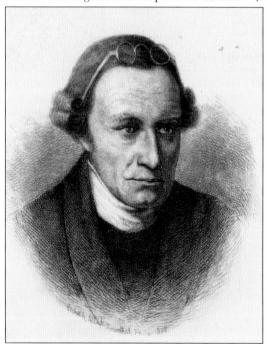

PATRICK HENRY. Perhaps the most emblematic figure in Hanover County history, Patrick Henry was born in 1736. By 1765, he was elected to the House of Burgesses, and Virginians sent him to the First Continental Congress in 1774. During the Revolution, he led troops in the "Gunpowder Expedition" at Williamsburg. By 1776, he became a three-term governor. In 1795, President Washington offered him the post of secretary of state, which he refused. He died in 1799 at the age of 63 at Red Hill. (Library of Congress.)

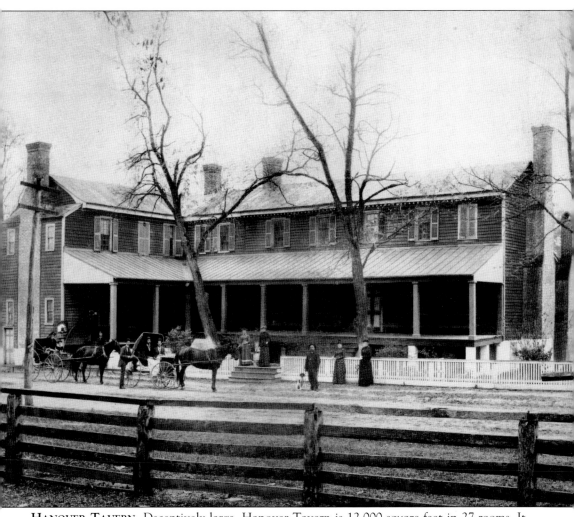

HANOVER TAVERN. Deceptively large, Hanover Tavern is 12,000 square feet in 27 rooms. It is configured from three distinct buildings that were connected sometime around the 1830s. Recent core samples from support timbers in the structure by dendrochronologists indicate the earliest section dates from 1791. Cornwallis's men were quartered here in an earlier structure on the site during the Revolution. It is believed that Edgar Allan Poe, Chief Justice John Marshall, and Charles Dickens visited the inn in the early 1800s. For many years, the tavern functioned as the local post office. The construction of railroad lines between Richmond and Fredericksburg around 1836 mitigated the need for stagecoach travel, and the tavern's trade vanished. Refugees of Civil War battles fled Union troops for the relative safety of the tavern. In 1953, when the tavern had fallen into disrepair, six actors from New York purchased it to put on productions that appealed to them. The Barksdale Theater was born. Recognized as a Virginia Historic Landmark, the tavern is being restored to the way it would have appeared in 1830. (Hanover Tavern Foundation.)

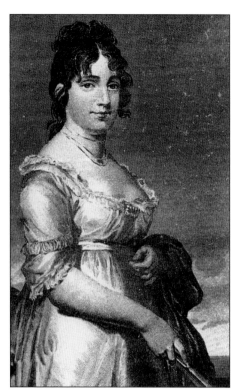

DOLLEY PAYNE (MADISON). Dolley Payne was a member of Cedar Creek Meeting House and a cousin of Patrick Henry. When the Paynes freed their slaves during the Revolution, they could no longer maintain a plantation and moved to Philadelphia, where Dolley married John Todd. A yellow fever epidemic left Dolley a widow. Aaron Burr introduced her to James Madison, many years her senior. A marriage was soon proposed. The decision to marry outside the Quaker faith would cost Dolley her lifelong membership in the church, but marry she did. She was often the official hostess for Thomas Jefferson and soon abandoned her Quaker gray for the lush fashion of the day. (Library of Congress.)

HENRY CLAY. Born in Hanover in 1777, Henry Clay would become one of the country's greatest orators at a time when public speaking was an art form. Some have said that only Andrew Jackson had more impact and only Daniel Webster could match him for oratory. Though a slaveholder himself, Clay is most remembered for the Compromise of 1859 that held the young country together for a time over the question of slavery. When he died in 1852, he was the first American to lie in state in the Capitol. (VCU Library.)

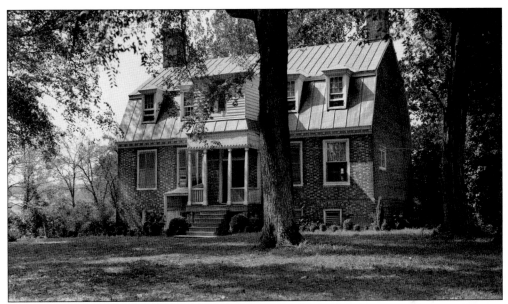

RURAL PLAINS. Rural Plains is often considered one of the oldest homes in Hanover County. The Shelton family and guests saw the wedding of Patrick Henry and his first wife, Sarah Shelton, on the lawn. During the Civil War, as the Battles of Totopotomoi Creek and Haw's Shop thundered through the Studley area, the family remained in the basement of the home as shells destroyed the cypress shingle roof and cannon balls struck the house. (Library of Congress.)

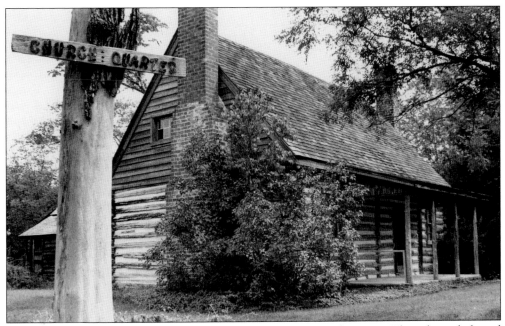

CHURCH QUARTER. Church Quarter was built on land patented in 1719. The cabin is believed to have been built between 1835 and 1850. The construction method and materials used support the notion that this may be the best preserved antebellum log dwelling in Hanover County. Church Quarter is listed on the National Register of Historic Places and the Virginia Register of Historic Landmarks. A marker on the highway tells the story. (*Herald-Progress.*)

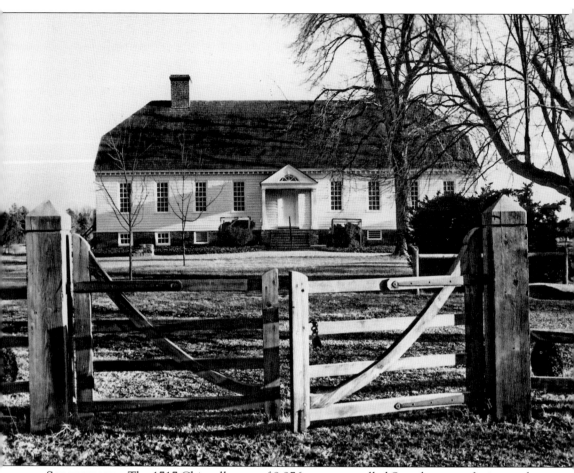

SCOTCHTOWN. The 1717 Chiswell grant of 9,976 acres was called Scotchtown, referring to the Scots who were imported to realize Chiswell's vision of mills, laundries, blacksmith shops, and even a castle. Soon after the main house, with its famous "jerkin-head" roof was built, Hanover experienced an outbreak of yellow fever that killed several workers at Scotchtown. Fearing for their lives, the remainder returned to Scotland. Work on the castle was stopped. When Patrick Henry became governor of Virginia, he bought the house and 960 acres in 1771. His wife became mysteriously ill and died there in 1775, and he left Hanover never to return. The house passed through a series of owners. In 1958, through the efforts of Noreen Campbell, a descendant of Patrick Henry, the Association for the Preservation of Virginia Antiquities acquired the house and began a restoration process. The house was opened in 1964. Scotchtown is on the National Register of Historical Landmarks. (*Herald-Progress.*)

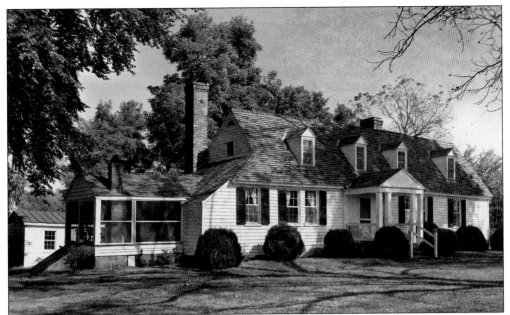

TAYLOR'S CREEK. It is believed that William Morris emigrated from Wales when he received crown grants totaling 10,000 acres in 1725, although perhaps not on contiguous property. By 1732, this home was built and named, perhaps for nearby Taylor's Creek, though some say the reverse is true. William's descendant Richard became the most famous member of the family, referred to as the "vox argentia" at the Continental Convention of 1829. After Richard's death, son Charles inherited the house and son Edward built Clazemont on the western portion of the property. Taylor's Creek has been remodeled several times and remains in the family today. (*Herald-Progress*.)

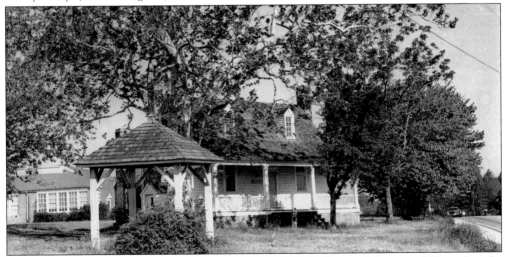

SYCAMORE TAVERN. Home to the Florence Page Memorial Library of History and Genealogy for more than 50 years, Sycamore Tavern is assumed to date from 1732. It is thought that the tavern was built on property offered as payment for the construction of nearby Taylor's Creek. Known as Higgason's Tavern and later as Shelburne's Tavern, this was the fourth stagecoach stop on the Richmond-to-Charlottesville route. In the early 20th century, Thomas Nelson Page founded a literary society (forerunner of the existing library) in his wife's name. (*Herald-Progress*.)

17

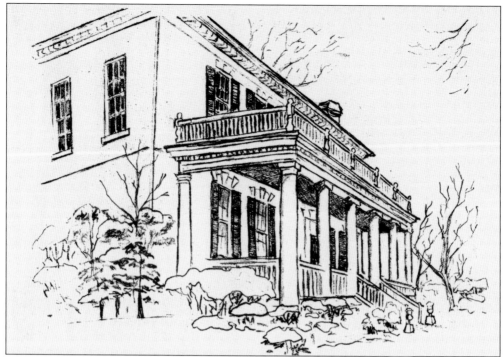

FRENCH HAY. The Marquis de Lafayette offered support and expertise to America during the Revolution. While in Hanover County, he stayed at a home on the west bank of Stoney Run near Lickinghole Creek where they both empty to the Chickahominy River. When he returned to France after the war, he sent a gift of special hay seed back to his host. The family named the property French Hay. (*Herald-Progress.*)

ROCKETTS. Rocketts was built around the same time as Fork Church, 40 years before the Revolution. Built of painted brick walls two feet thick with handmade nails, the house is two stories in front and three in the rear to accommodate the steep site. A building on the property served as a post office during the Revolution. No one can remember when the old mill wasn't standing at the foot of the hill, and the property is often referred to as Rockett's Mill. (*Herald-Progress.*)

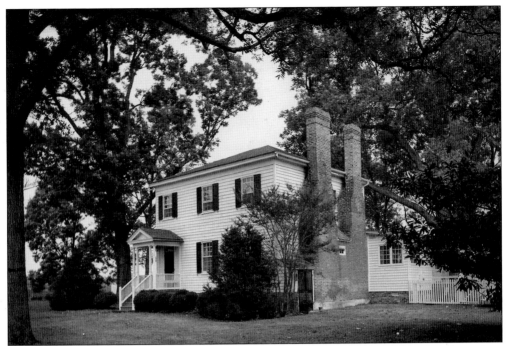

MARL RIDGE. The name Marl Ridge derives from the green marl deposits found in the soil on the property. Built to be earthquake proof, it has always been the home of the Wingfield family. Withstanding Tarleton and Sheridan in two different wars, the home has probably stood since the early 1700s. Lois Wingfield Wickham, who was born in the 1920s at Marl Ridge, told Aldon Aaroe in a 1990s interview that she learned to work the farm herself after the death of her father. (*Herald-Progress.*)

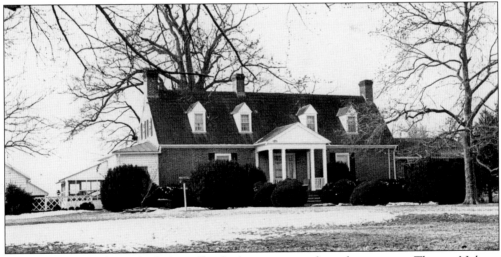

AIRWELL. The land on which Airwell is built was a grant from the crown to Thomas Nelson, whose grandson constructed the house around 1763 when he paid "seven pounds ten shillings for all work done." The home remained in the Berkeley family until it was destroyed by fire in 1836. Mary Edmonia Berkeley, heiress of the property, married Calendar St. George Noland in 1843. After repairs, they lived in the home until 1871. The house was destroyed again by fire in 1936. It was rebuilt as it stands today. (*Herald-Progress.*)

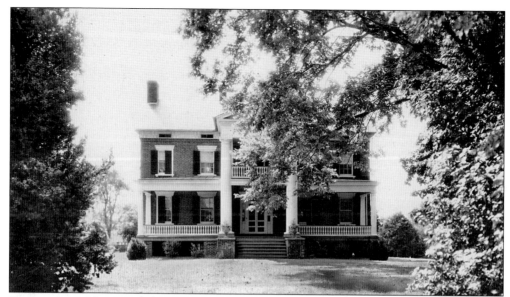

BEAVERDAM. Often remembered as the place where Flora Stuart got the news of Gen. J.E.B. Stuart's fatal wounding at Yellow Tavern in 1864, Beaverdam was owned then by Edmund Fontaine, president of the Virginia Central Railroad. He also served as a state senator from 1834 until 1842. Owned for generations by the Fontaine family, the home was built around 1790 by the original owners, Col. William Fontaine and wife, Anne Morris, from Taylor's Creek. The colonel served during the Revolutionary War and is said to have seen Cornwallis surrender in Yorktown. (*Herald-Progress.*)

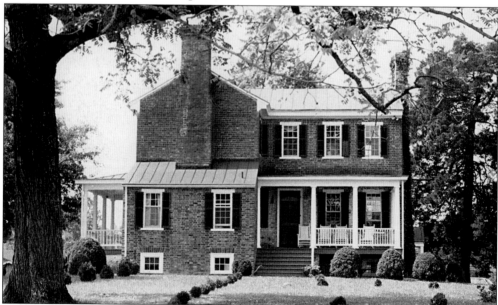

COOL WATER. Mary Randolph married John Price, and they built Cool Water on 1,500 acres between 1735 and 1740. Their son, Capt. Thomas Price, was an officer in the American Revolution and served under Patrick Henry in the march to Williamsburg in the Gunpowder Expedition. The bricks used for the Flemish bond construction of the walls were made on the property. (*Herald-Progress.*)

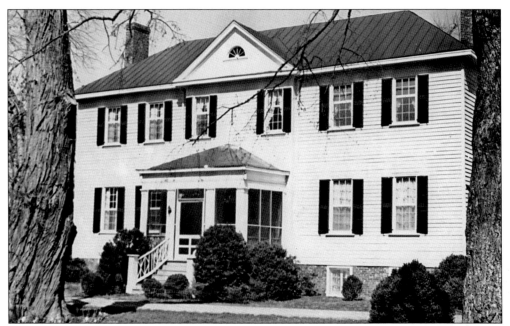

SUMMER HILL, A STRONGHOLD OF THE PAGE FAMILY. Around 1672, Mann Page received a 1,700-acre grant and laid off 100 acres in lots at Page's Warehouse, later Hanovertown. One story tells of a young soldier, Capt. William Latane, killed in a nearby battle in 1862. With no men about, the ladies of Summer Hill and Westwood held services and the burial. The house was a Federal hospital during the Seven Days' Battles. (*Herald-Progress*.)

SOUTH WALES. South Wales dates to the early 1700s, part of an enormous tract of land that stretched from Littlepage's Ferry across the Pamunkey to the Hanover Courthouse. Lewis Littlepage was made ambassador to Poland and apparently was often received in the court of Catherine the Great. Today, Dr. Hill Carter owns the farm, which has been significantly expanded. (*Herald-Progress*.)

OAKLAND. The original house was built in 1812 on a 3,300-acre, 1718 land grant from the crown. Oakland was first the home of Capt. Thomas Nelson. Thomas Nelson Page wrote *Two Little Confederates*, a story of Hanover during the War Between the States, at Oakland. He became America's ambassador to Italy during the First World War. The well-loved historian Rosewell Page Jr. long made Oakland his home. The site is on the Virginia Register of Historic Landmarks. (*Herald-Progress.*)

MEDLEY GROVE. Today, the Brookmeade Sod Farm operates at Medley Grove, believed to have been built around 1731, about the same time as the nearby Cedar Creek Meeting House where generations of Quakers held sway. The Harris family occupied the home for many years until it was purchased by William Thomas Priddy. Also called Happy Hollow, the house was bought by Mary and John Workman in 1950. Mary, known as "Sunshine Sue," was the "Femcee" of the Old Dominion Barn Dance on WRVA radio during the 1940s and 1950s. (*Herald-Progress.*)

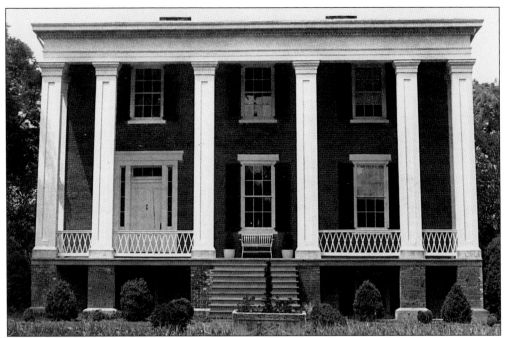

CLOVERLEA. This fine example of the Greek revival style, almost unique in Hanover architecture, was built by the Bassett family in 1844 in the Old Church area. During the Civil War, Union troops assaulted the front door with rifle butts, anxious to capture J.E.B. Stuart, whom they believed to be inside. Their aggressive pounding splintered the solid walnut door panels, which were purposely left unrepaired after the war. The Bassett family was forced to the top floor of the home as the Union Army conscripted their home and camped on the front lawns. Cloverlea is listed on the National Register of Historic Places and the Virginia Register of Historic Landmarks. (*Herald-Progress.*)

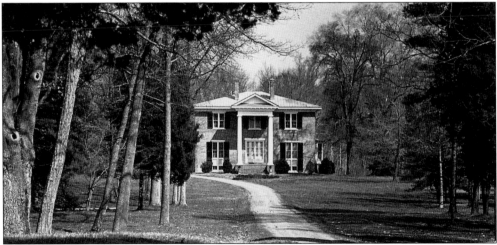

DITCHLEY. Records show that the original owner of this property was John Kilby of Revolutionary War fame. While it can be established that the property was sold by Kilby to George W. Robineau, then to Williamson Tomlin, there is no known date of the construction of the elegant Ditchley. Owners have maintained the character of the old estate by replenishing woods and marbles from other old homes that have had less fortunate histories. (*Herald-Progress.*)

23

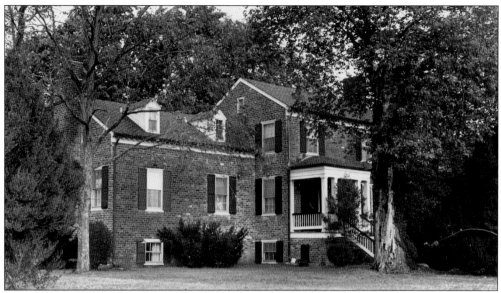

EAGLE POINT FARM. In 1840, Francis Blunt, who had a mill nearby, built Eagle Point Farm. Today, the Gilman family has transformed the property into a horse farm with a long row of stables set among rolling green hills on which fine horses can be seen grazing. (*Herald-Progress.*)

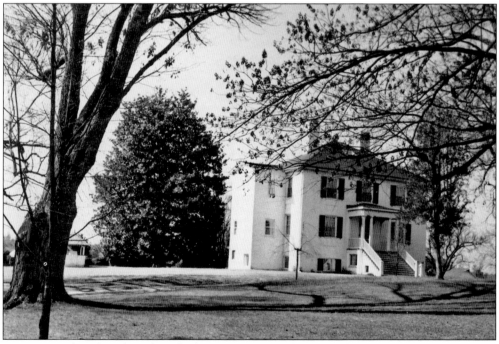

INGLESIDE. Thought to have been built sometime around 1838, Ingleside was the home of Carter Braxton, whose grandfather of the same name was a signer of the Declaration of Independence. It was the headquarters of General Grant during the Battle of Cold Harbor. Ingleside's reputation for hospitality and lively entertainment was known far and wide. (*Herald-Progress.*)

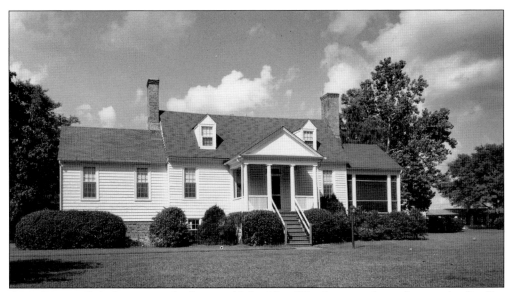

OAK GROVE. Oak Grove was the home of John Haw III, whose machine shop in the Studley area was the site of a fierce battle during the Civil War. The home is thought to have been built between 1785 and 1790. All five of the Haw boys fought in the Civil War. At one time, the area around Oak Grove was called Hawsville. The name was later changed to Studley to honor Patrick Henry's birthplace. (*Herald-Progress.*)

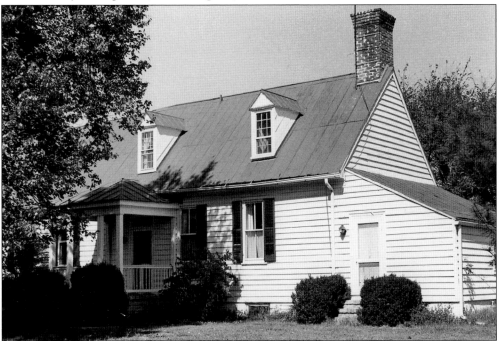

BEAR ISLAND. Bear Island, long the home of the Gwathmeys, is said to be haunted by the ghost of John Brown. Before the raid on Harpers Ferry, he spent the night at Bear Island. During the night, he is said to have incited the servants to murder the family. When they recoiled, he sneaked away. Days later, when the raid was news, the Gwathmeys realized their elusive guest was none other than John Brown. (*Herald-Progress.*)

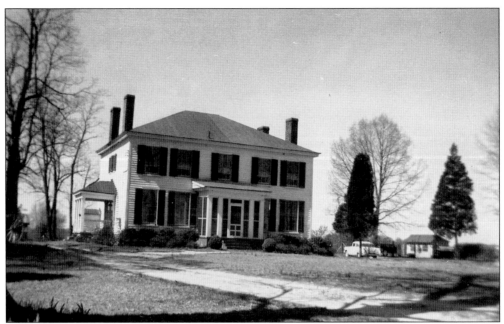

LOCKWOOD. Notable on its own for its exemplary architecture, Lockwood became the headquarters of Robert E. Lee in May of 1864 during his tangle with Grant's army in the Overland Campaign. Ill at the time, Lee was compelled to rest at this home until he recovered. (*Herald-Progress.*)

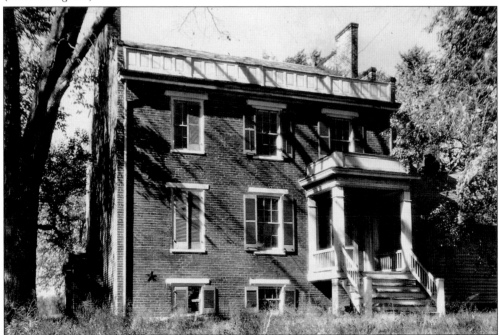

CLAZEMONT. This fortress home, with brick walls 20 inches thick, was built by Edward Morris on land he inherited from his father. All of the timber used in construction was taken from the property. After the fire that razed Montpelier High School, classes were conducted at Clazemont until a new facility could be constructed. (*Herald-Progress.*)

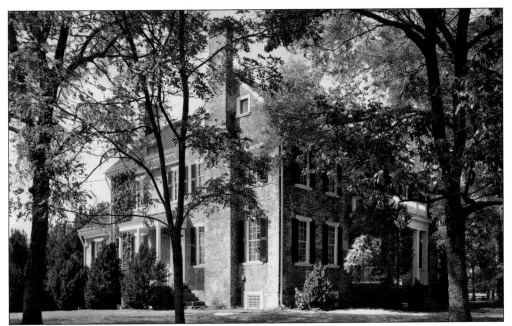

WILLIAMSVILLE. The date of this home is inscribed in bricks over the front door: 1803. The name derives from its owner, William Pollard, clerk of Hanover County from 1781 to 1824. Pollard succeeded his father, who had been clerk for the 41 years prior. The tapestry of Williamsville's history is woven by several families known well in Virginia: Pollard, Haw, Dabney, Darracott, Shepard, Shackleford, Peachey, Todd, and Cabannis. It has always been known for its beautiful gardens and hospitality. (*Herald-Progress.*)

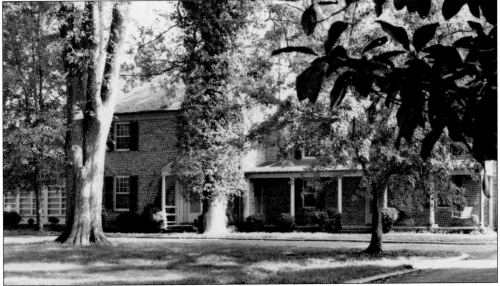

COURTLAND. Located quite close to Hanover Courthouse, the home once belonged to the Pollard family but was sold around 1842 to William Overton Winston, deputy clerk under Mr. Pollard. According to the *Old Homes of Hanover County*, "During the battle of Hanover courthouse the Federal Troops were on the courthouse hill and the Confederates placed their guns in Courtland yard." (*Herald-Progress.*)

HICKORY HILL. When William Fanning Wickam married Anne Carter of Shirley Plantation (on the James), Hickory Hill became a far-flung adjunct to the larger plantation. Although the original home was destroyed by fire in 1875 or 1876, it was quickly rebuilt. During the Civil War, Mrs. Robert E. Lee is said to have brought her daughters here to stay. Sen. Henry Taylor Wickham, pictured here in the 1930s, served in the Virginia House of Delegates and the senate until he died in 1943. (*Herald-Progress.*)

RUG SWAMP. It is thought that Thomas Nelson Jr. bought this property for his daughter, Suky, who married Francis Page, son of Gov. John Page of Rosewell in Gloucester County. When historian Rosewell Page's grandfather was born in this house, word got out that the Pages named their son after the old Page place. One Hanover lady was heard to say, "Well, for the Lord's sake, I don't see why Miss Betsey couldn't have found a better name for their baby than 'Rug Swamp'!" The child was called Rosewell. (Barbara Jones.)

Two

THE CIVIL WAR

UNION SUPPLY BOATS. At the outset of the Union Army's push for Richmond during the Peninsula Campaign of 1862, both Lincoln and Davis lacked confidence in their generals. Union General McClellan had continually balked at real conflict, leaving Lincoln to wonder if he would ever mount an attack. Davis had confided to his advisor, Robert E. Lee, that General Johnston seemed ineffectual and secretive. The Peninsula battles would see each President make sweeping changes in command. Early in the campaign, Lincoln trimmed McClellan's authority so he commanded only the Army of the Potomac. With 92,000 men, he was ordered to land at Urbanna, move up the York River to White House Landing on the Pamunkey, and on to Richmond. Johnston moved roughly 38,000 men to defend the banks of the Chickahominy and Richmond. After the Battle of Seven Pines, Davis would replace Johnston and put Robert E. Lee in command of the Army of Northern Virginia. Richmond would be spared for two more years. (Library of Congress.)

GEN. JOSEPH E. JOHNSTON, WEST POINT CLASS OF 1829. In 1861, quarrels over relative ranking created mutual animosity between Johnston and President Davis. Wounded and relieved of command during the Peninsula Campaign, Johnston was given command of the Department of the West upon recovery. Again, he was relieved of command. He was reinstated because of congressional opposition to his dismissal. After the war, he served as a railroad commissioner. He died after contracting a cold when he attended Sherman's funeral. (Library of Congress.)

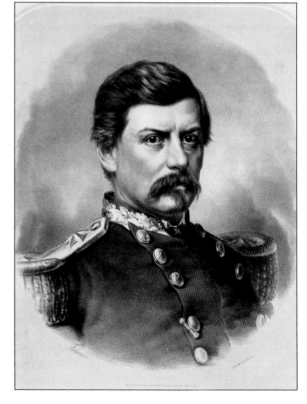

GEN. GEORGE BRINTON McCLELLAN, WEST POINT CLASS OF 1845. McClellan was revered by his troops, probably because he rarely got around to actually using them. His arrogance toward authority figures like Wingfield Scott and Abraham Lincoln earned him the nickname "Young Napoleon." Overestimation of his enemy's strength paralyzed him. After repeatedly withdrawing his forces in the face of what he falsely believed to be overwhelming Confederate forces during the Peninsula Campaign, he was forced to retreat without taking Richmond. Months later, Lincoln grew tired of his consistent reluctance to carry out orders and relieved him of command. He was never reinstated. He ran against Lincoln for President in 1864 and resigned from the army after his defeat. (Library of Congress.)

30

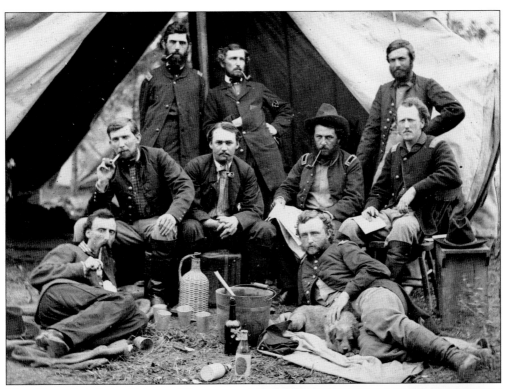

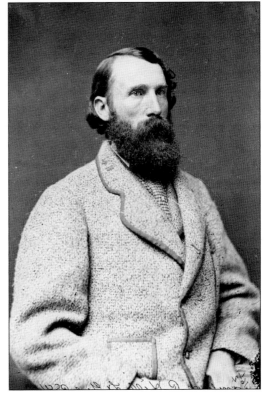

MAJ. GEN. FITZ JOHN PORTER, WEST POINT CLASS OF 1845. Porter was a friend and contemporary of Union General McClellan. During the Seven Days' Battles, fought in neighboring Henrico County, he distinguished himself, yet after the Second Battle of Bull Run, Porter was court-martialed for insubordination. He spent the rest of his life trying to clear his name. Above he is pictured (standing far right) with his staff during the Peninsula Campaign. George Custer is reclining with the dog. (Library of Congress.)

LT. GEN. A.P. HILL, WEST POINT CLASS OF 1847. Born in Culpepper in 1825, Hill is variously called Little Powell, The General in the Red Battle Shirt, and The Mystery Man of the Confederacy. He directed the fighting at Hanover Courthouse and distinguished himself during the Seven Days' Battles. He was shot and killed on April 2, 1865, having risen from his sickbed to try to rally his collapsing line. Lee said, "He is at rest . . . and we who are left are the ones to suffer." (Library of Congress.)

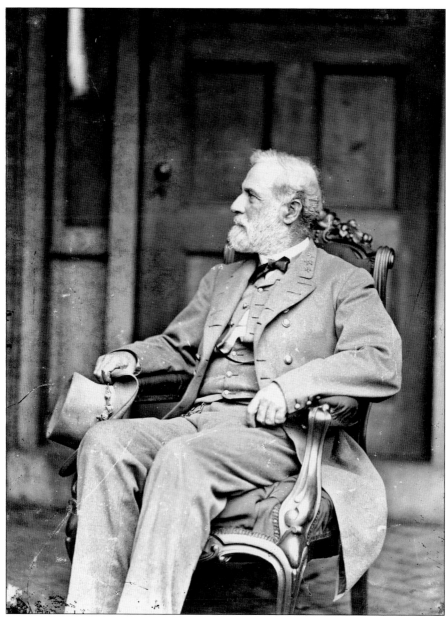

GEN. ROBERT E. LEE, WEST POINT CLASS OF 1829. "Marse Robert" remains a Southern idol. Lee was called to Richmond in 1862 as an advisor to Jefferson Davis. The President allowed Lee considerable influence over troop operations, especially in view of the fact that he mistrusted Joe Johnston. Put in command of the newly named Army of Northern Virginia after Johnston's wounding at Seven Pines, Lee may have been helped as much by McClellan's timidity as his own strategy. The result of the Peninsula Campaign was that McClellan was kept from the very gates of Richmond. Lee would distinguish himself and his soldiers for another two years. After the war, he returned to Richmond and set himself as the example to defeated soldiers who needed to put the war behind them and rejoin the United States of America. Refusing all other offers, he became president of Washington College, later named Washington and Lee University. He died in 1870 of heart disease and was buried at Lexington. (Library of Congress.)

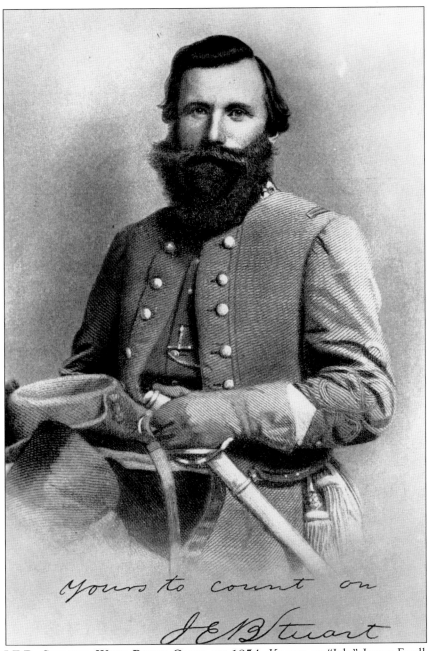

Yours to count on

J E B Stuart

GEN. J.E.B. STUART, WEST POINT CLASS OF 1854. Known as "Jeb," James Ewell Brown Stuart may be the most famous cavalryman of the Civil War. On June 12, before the Battle of Gaines' Mill, Lee sent J.E.B. Stuart to scout McClellan's northern flank. Stuart took a full brigade (about 1,100 riders) not just around the Union flank, but around the whole army. In three days, he marched 150 miles, destroyed supplies, captured several hundred prisoners, and came back with the desired intelligence. He also came back with almost his entire command, having lost only one man. Stuart was to remain vital to Lee's defense again in the Overland Campaign of 1864. In an ironic twist of fate, he was killed at Yellow Tavern in May of 1864, the one-year anniversary of the death of Stonewall Jackson. (Library of Congress.)

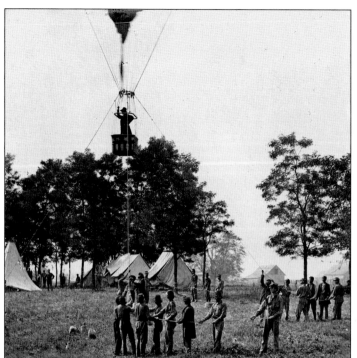

HIGH TECH RECON. The Civil War saw the first use of balloons for military operations. Thaddeus Lowe created the first aeronautic service. His five balloons provided strategic advantages to Union troops during the campaigns in Virginia, especially the Peninsula effort of 1862. His published diaries show his signature as "T.S. Lowe, Chief Aeronaut." (Library of Congress.)

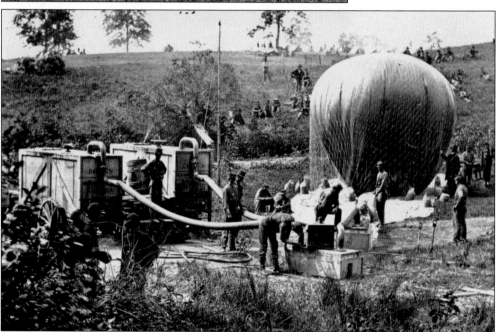

LOWE'S DIARY. A selection from Lowe's diary reads: "General McClellan sent orders to me to proceed with my outfit, including all the balloons, gas-generators, the balloon-inflating boat, gunboat, and tug up the Pamunkey River, until I reached White House Landing. . . . I took observations to ascertain the best location for crossing the Chickahominy River. The one selected was where the Grapevine Bridge was built. . . . My main station and personal camp was on Gaines' Hill, overlooking the bridge." (Library of Congress.)

INTREPID. This particular balloon was used to observe Confederate troop movement during the Battle of Gaines' Mill. At Mechanicsville, Confederate soldiers masked 12 of their best rifle-cannon and simultaneously discharged them at short range. Some of the shells passed through the rigging of the balloon and nearly destroyed it. (Library of Congress.)

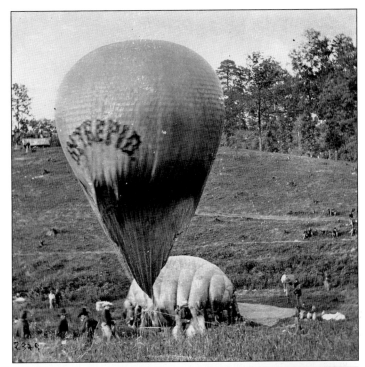

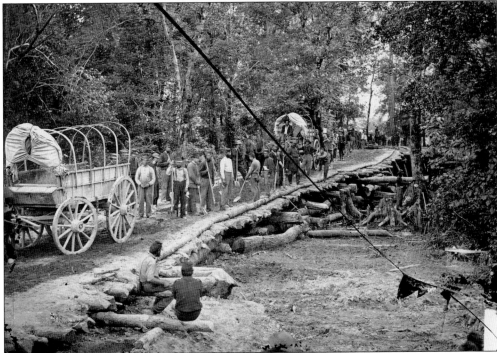

GRAPEVINE BRIDGE. By late May 1862, Union troops straddled the Chickahominy, so swollen by the worst rains in 20 years that 11 pontoon bridges had to be constructed from Mechanicsville to Bottom's Bridge. Pictured here is the Grapevine Bridge, built by the 5th New Hampshire Infantry and observed by Lowe in his balloon. (Library of Congress.)

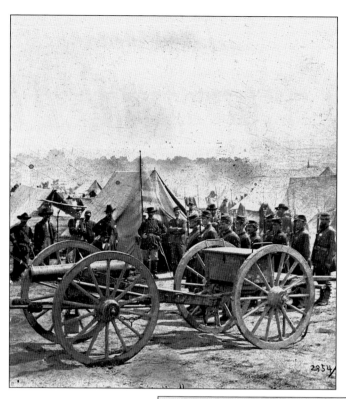

BATTLE OF HANOVER COURTHOUSE, 1862. As ever, McClellan feared his army outnumbered. To strengthen his northern flank, he sent Brig. Gen. Fitz John Porter with a division north to Hanover Courthouse. On May 27, Porter's troops encountered a retreating Confederate brigade. Without much contest, the Union troops captured a howitzer and two supply trains. Pictured here is a 12-pounder howitzer gun captured by Butterfield's Brigade near Hanover Courthouse that day. (Library of Congress.)

BATTLE OF SEVEN PINES, 1862. On May 31, Johnston tried to overwhelm two of the Union groups isolated on the south side of the Chickahominy River. His attack plan was ill conceived but did succeed in driving back the Union forces. After reinforcement on both sides, action continued, with Union troops finally crossing the Grapevine Bridge. General Johnston was seriously wounded; command was handed over to Maj. Gen. G.W. Smith until Jefferson Davis could order Robert E. Lee to assume command of the newly named Army of Northern Virginia. (Library of Congress.)

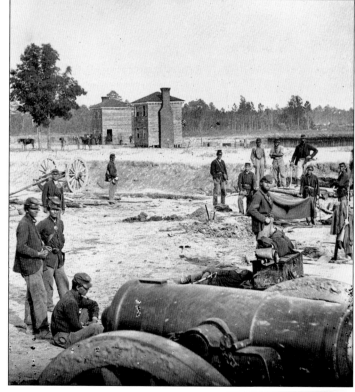

ELLERSON'S MILL, 1862. The Seven Days' Battles began at Ellerson's Mill in Mechanicsville. Stonewall Jackson was to march from Ashland on June 25. Before dawn on June 26, he was to attack Porter at Beaverdam Creek, or Ellerson's Mill. Lee wrote, "A.P. Hill was to cross the Chickahominy at Meadow Bridge when Jackson's advance beyond that point should be known." Jackson never arrived. Union troops held strong positions on ridges above the creek. A.P. Hill's soldiers were cut down easily. At the end of the day, Confederate casualties numbered nearly 1,500; Federal losses were slightly more than 250. (Library of Congress.)

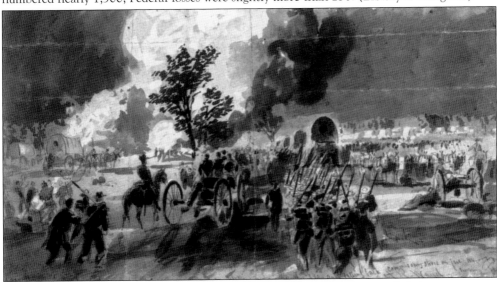

BATTLE OF GAINES' MILL, 1862. After Ellerson's Mill, McClellan needed time to remove supplies from White House Landing to Harrison's Landing. His orders to Porter, who was headquartered at the Watt House, were to hold his position until nightfall. Nearly 35,000 Union troops would have to hold against 60,000 Confederates. Lee's forces charged all day on June 28. As one veteran said, "The noise of the musketry was not tattling . . . but one intense metallic din." By day's end, 15,000 were dead in a near draw. Lee had succeeded in removing Federal troops from the north side of the Chickahominy River. McClellan got the time he needed to re-establish his supply base. The immediate threat to Richmond had passed. (Library of Congress.)

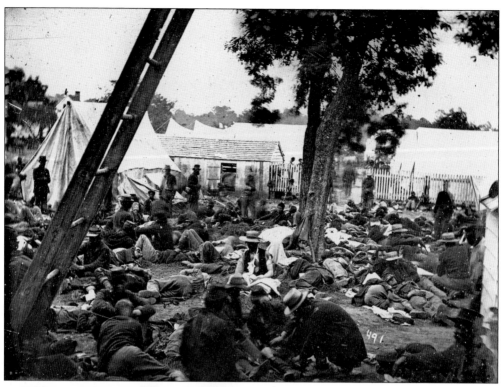

BATTLE OF SAVAGE'S STATION, 1862.
After Gaines' Mill, McClellan was in a
defensive position. Lincoln told him to
hold his army at any cost. Beginning the
third of the Seven Days' Battles, Lee
attacked on June 29 at Savage's Station,
but it was mounted too late and without
Stonewall Jackson's troops, which should
have arrived earlier in the day. McClellan
was able to withdraw to relative safety but
had to abandon his field hospital, leaving
more than 2,000 wounded and sick at the
mercy of the Confederate Army. (Library
of Congress.)

**BATTLE OF FRAYSER'S FARM, OR WHITE
OAK, 1862.** Union troops were not
accustomed to the boggy misery of
summertime in Hanover County along the
banks of its rivers and in its labyrinthine
swamps. When fighting ended on June 30
at White Oak Swamp, combatants had
engaged in hand-to-hand combat. The
fourth battle of the Seven Days had failed
to give Lee any advantage. He had to
abandon the notion of severing McClellan's
army in two. (Library of Congress.)

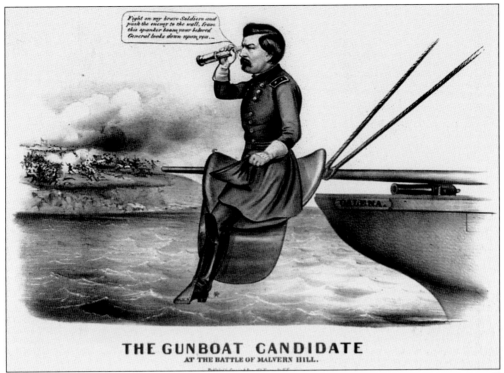

THE GUNBOAT CANDIDATE
AT THE BATTLE OF MALVERN HILL.

MALVERN HILL, 1862. Malvern Hill was the last of the Seven Days' Battles. Gen. D.H. Hill said, "It was not war. It was murder." The Confederate side lost 5,300 to Union artillery occupying the high ground. Yet despite his easy victory, McClellan again withdrew, this time to the James. This political cartoon lampoons him when he ran for President against Lincoln in 1864. He calls to his troops from the Galena while the Battle of Malvern Hill rages on in the distance: "Fight on my brave Soldiers and push the enemy to the wall, from this spanker boom your beloved General looks down upon you." (Library of Congress.)

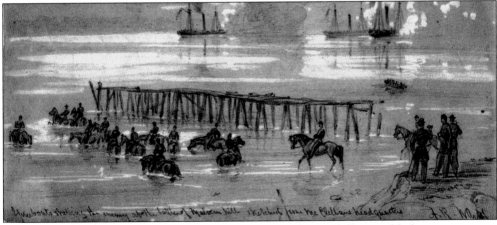

GUNBOATS SHELLING MALVERN HILL, 1862. Although McClellan could claim a victory at Malvern Hill, he withdrew to entrench at Harrison's Landing, where his army was protected by gunboats. This ended the Peninsula Campaign. The threat to Richmond ended, and Lee sent Stonewall Jackson to fight against Maj. Gen. John Pope's army along the Rapidan River. (Library of Congress.)

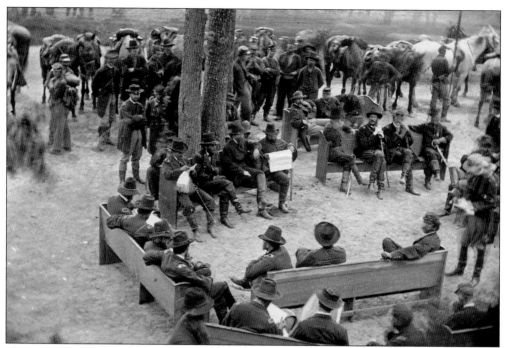

GRANT'S WAR COUNCIL. By 1864, Ulysses S. Grant was in charge of Federal armies. Following the botched Peninsula Campaign of McClellan, Grant and Lee had met at Antietam, Chancellorsville, and Gettysburg. In the summer of 1864, Lee's army moved into Virginia. Grant began his Overland Campaign, vowing to find and destroy Lee's army. Beginning with the Wilderness battles around Fredericksburg, Grant began a march to Richmond that would end in the Battle of Cold Harbor and a second lost opportunity to capture Richmond. These battles would be some of the costliest and bloodiest of the war. (Library of Congress.)

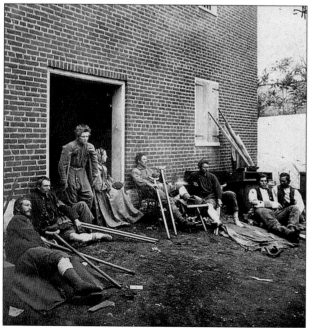

THE WILDERNESS. Fighting began on May 5, 1864, along the Orange Turnpike and the Plank Road. Fighting was chaotic and certainly inconclusive, as both sides had to negotiate battle in forests. Nearly 18,000 Union soldiers lost their lives, including General Wadsworth and General Hays. Confederate losses were 11,000. Generals Jones, Jenkins, and Stafford were killed. Though technically a draw, Grant, unlike McClellan before him, did not withdraw and advanced toward Hanover County and Richmond. (Library of Congress.)

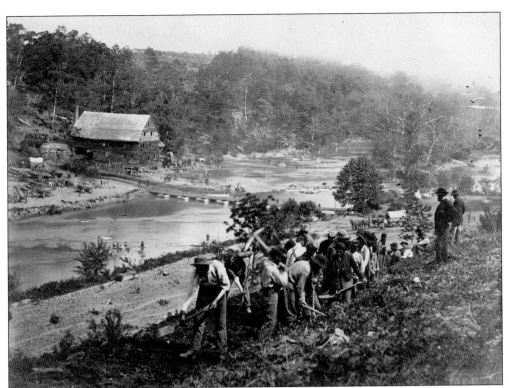

NORTH ANNA BATTLE. Variously called the Battle of Jericho Mills, Quarles Mills, and the Battle of North Anna, it was the beginning of the Overland Campaign in Virginia. Near the end of May, Union and Confederate forces bristled along the banks of the North Anna River. Grant's march was stopped short by Lee's famous "hog snout line," which forced Grant to divide his army into three parts. On May 23, 1864, one of A.P. Hill's divisions assaulted Union troops that had crossed the river at Jericho Mills. On May 24, Union infantry was repulsed at Ox Ford (the snout). Lee had been ill and was unable to complete the offensive. Grant regrouped across the river and outflanked Lee's army further downstream. The Richmond, Fredericksburg and Potomac Railroad Bridge was destroyed during the fighting. The march to Richmond continued. (Library of Congress.)

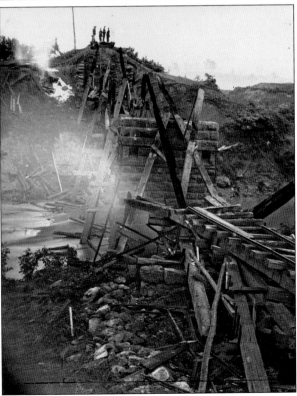

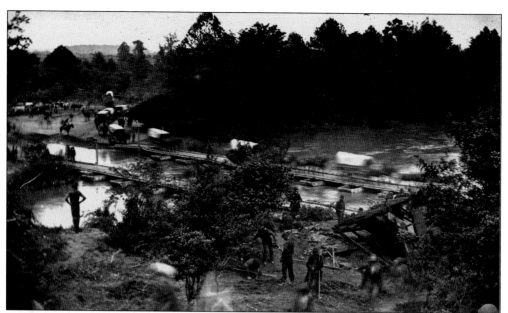

TOTOPOTOMOI CREEK, 1864. Grant's men moved downstream and forded the Pamunkey at the old location of Hanovertown or Dabney's Ferry across pontoon bridges. The Battle of Totopotomoi Creek—also called Bethesda Church, Haw's Shop, and Matedequin Creek—was particularly difficult, as most of it was fought hand to hand by dismounted cavalry. Reinforcements for both sides began to arrive around Old Church and Cold Harbor as the fighting raged. Nearly 800 men died in the seven-hour battle. The Federals were temporarily stopped but the relentless wave of Grant's army would not be. (Library of Congress.)

COLD HARBOR, 1864. On May 31, Sheridan's cavalry seized all important crossroads of Cold Harbor. They are pictured here in front of the Cold Harbor Tavern. The actions at Cold Harbor changed the course of the war in the East from a war of maneuver to one of siege. Cold Harbor also influenced the strategy and tactics of future wars by demonstrating that well-selected, well-manned entrenchments, supported by artillery, were practically impregnable against frontal assaults. (Library of Congress.)

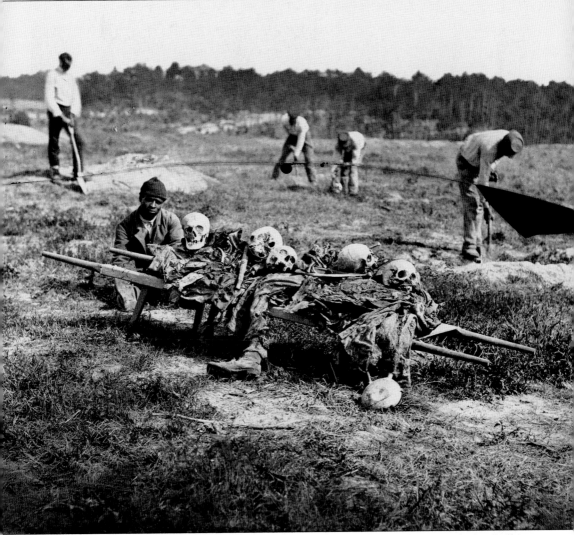

BATTLE AFTERMATH, 1864. On June 1, dismounted Confederate infantry attacked a shallow Union entrenchment. Armed with repeating carbines, the Federals quickly repulsed the attack. Reinforcement from Richmond and the Totopotomoi Creek Lines arrived. Late on June 1, the Union reinforcements reached Cold Harbor and assaulted the Confederates with some success, but by June 3, both armies had regrouped and were on the field, forming a seven-mile front that extended from Bethesda Church to the Chickahominy River. At dawn on June 3, Grant recklessly ordered his men to attack Confederate breastworks. In just 20 minutes, 8,000 Union soldiers were literally slaughtered. Grant was to write in an autobiography that this was the only attack he wished he had never ordered. Grant's army would be thwarted again in its drive to Richmond. (Library of Congress.)

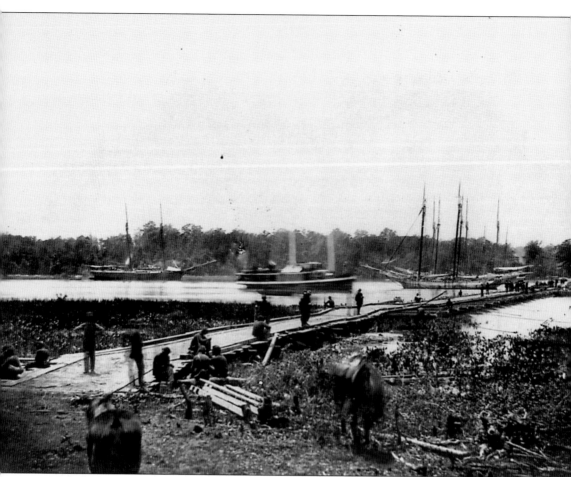

RETREAT TO THE JAMES AND PETERSBURG, 1864. Moving on to Petersburg, the armies confronted each other on these lines until the night of June 12, when Grant again advanced by his left flank, marching to the James River. On June 14, Union troops crossed the river at Wilcox's Landing by transports. On June 15, the rest of the army began crossing on a 2,200-foot-long pontoon bridge at Weyanoke. Abandoning the well-defended approaches to Richmond, Grant sought to shift his army quickly south of the river to threaten Petersburg. It would be another year before the end of the war. (Library of Congress.)

Three
SOLDIERS

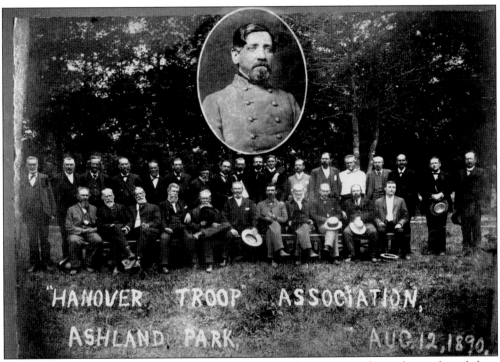

CO. G, 4TH VIRGINIA CAVALRY REUNION, 1890. This reunion photo shows, from left to right, (seated) Charles Coleman Taylor, Joseph Booth Brown, Walter Leake Wingfield, Peter Winston Wingfield, David D. Waldrop, Daniel Algernon Timberlake, John Lewis Greene, Martin Alpheus Waldrop, James Churchill Cooke, Asbury Watson Brock, and Luther Boxley Vaughan; (standing) John H. Blunt, Thomas Franklin Tyler, Jno. Henry Timberlake, Chastain Rufus Wingfield, Robert Lee Priddy, Alex Jackson, William Edward Carter, Charles Alexandria Taylor, John James Terry, John Lewis Talley, William Johnson Binford, Thomas Buchanan Dunn, J. Alexander Brown, Edmund Pleasant Winston, Francis Edgar Wright, John Richard Gilman, Judge Jno. Jeter Crutchfield, and Thomas Ellett Gilman. Gen. Williams C. Wickham is featured in the inset. (Woody and Susan Tucker.)

HANOVER LIGHT DRAGOON.
John Harris Blunt, whose father
built Eagle Point Farm, was a
member of Co. G, 4th Virginia.
(Woody and Susan Tucker.)

ASHLAND GRAYS. Callum
B. Jones was a member of
Co. E, 15th Virginia
Infantry, which saw action
during the Civil War. He
was paroled at Appomattox
Courthouse in April 1865.
Jones graduated from the
Medical College of Virginia
in 1869 and later established
a private practice in
Ashland in 1882. (Woody
and Susan Tucker.)

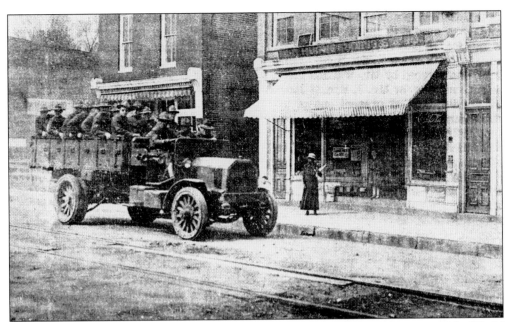

LIBERTY DAY BOND DRIVE. Recruitment events and bond drives were important to the World War I war effort. In April 1918, a parade down Railroad Avenue included F.W. Tucker and his Ashland Grays, six carriages of dignitaries, the boy scouts, and others. (*Herald-Progress.*)

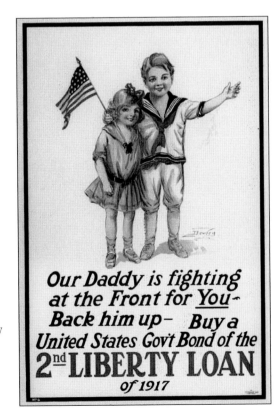

BUY WAR BONDS. To finance the war effort, families were given papers to display and demonstrate their contributions. Merchants sponsored ads like this one in local newspapers. Employees could subscribe for payroll deductions. (Library of Congress.)

47

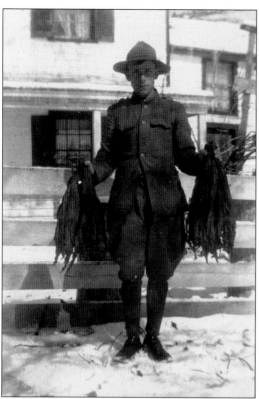

WORLD WAR I IN MONTPELIER. Chester Stanley displays some cured tobacco to a buddy while home on leave at the Hillary Baughan home. (Barbara Jones.)

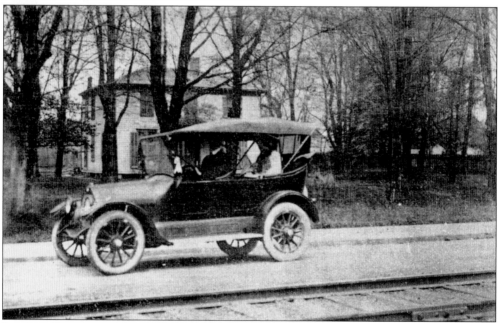

LIBERTY DAY PARADE. At the town lot, the Liberty Day Parade of 1918 ended with the Honorable Henry T. Wickham and Sen. Claude Swanson entertaining the crowd with patriotic speeches. The rally was closed with a vaudeville act—"Minnie the Wild Girl" and her snakes. (*Herald-Progress.*)

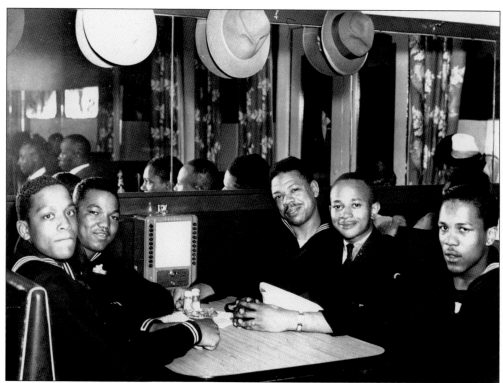

WORLD WAR II. Hanover families have always sent their sons to fight for liberty. Above, James Lee Johnson (second from left) shares some free time with buddies in San Diego in 1942. The picture at right shows James Talley (left) with his pals, also taken in San Diego in 1942. Black or white, our boys fought and played together as cohesive, if separate, units. (Above, Hanover County Black Heritage Society; Right, Dale Talley.)

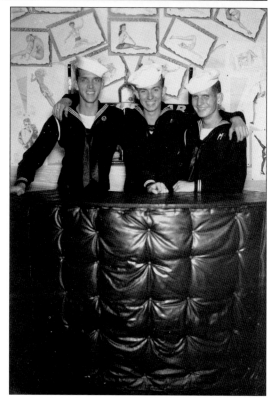

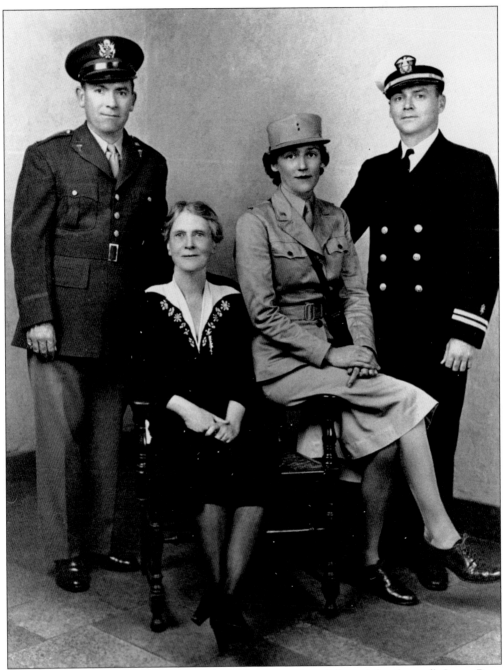

THE NELSONS IN THEIR UNIFORMS. The Nelsons are, from left to right, (seated) Susan Rose Pleasants Morris Nelson, whose children represent the U.S. Army, Women's Army Auxiliary Corps (WAACS), and U.S. Navy; and Louise Bolling Nelson (later Mrs. William Hugh Redd); (standing) Dr. Kinloch Nelson and Dr. Charles Morris Nelson. (Anne Nelson.)

Four

FARM LIFE

FARM VISTA. Throughout its history, Hanover has been an agricultural, rural community that relied on what could be produced from the soil. Bisected by the Blue Ridge fall line (Interstate 95), the county has two distinct soil types. To the east is the flat coastal plain of Tidewater with its sandy loam ideal for producing vegetables and melons. To the west, the ground of the Piedmont is more suited to grain production, timbering, and growing tobacco. Before the Civil War, farms were quite large, often thousands of acres. After the war, many of the large planters had lost a good deal of their land. Freed slaves and tenant farmers began to have small acreages from which they eked out a living. Families of the larger plantations tried to find a way to cope with diminished lands and work force. (*Herald-Progress.*)

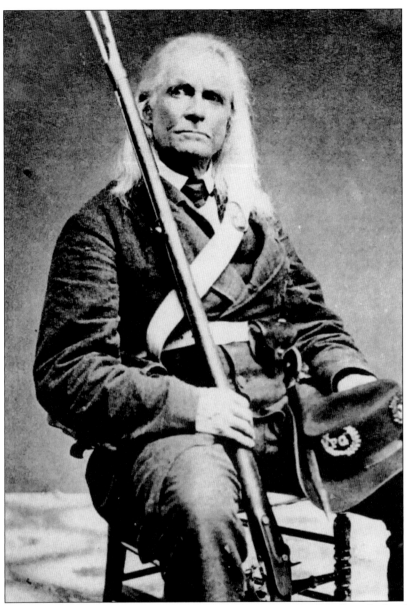

EDMUND RUFFIN. In the period before 1860, Edmund Ruffin introduced methods of farming through the use of green sand, marl, and oyster shell lime freely applied to soils. The practice so increased crop fertility that, to quote Ruffin, "seventeen million dollars were added to the assessed value of the land in (eastern Hanover) between the years 1830 and 1850." According to historian R.B. Lancaster: "He served in the Virginia State Legislature and on the State Board of Agriculture. For ten years he edited *The Farmer's Register*, at the time the most widely read farm magazine in America. In 1843 he bought an estate in Lower Hanover now known as Marlbourne. An ardent advocate of slavery and secession, he published several pamphlets on the subject. At the age of sixty-seven he volunteered for service in the Confederate Army and at Fort Sumter it is said that he fired the first shot of the Civil War. . . . Ruffin served as a Confederate soldier until he was seventy-one years of age. When the Confederacy fell, he took his own life rather than live under the Union. He is buried at Marlbourne." (Library of Congress.)

AFTER THE WAR. The war changed everything. Large farms were lost, and entire families lost their livelihood. Properties were auctioned off. By 1930, there were approximately 1,954 farms in Hanover covering a land area of approximately 327,680 acres. Nearly all of the larger operations had gone. Many families never recovered. (Alan Smith.)

SLAVE SALE RECEIPT. It is still incredible to believe that people were bought and sold. Here is an idea of what it cost. In 1856, a farmer bought a woman named Amanda and her two children for $1,225. They had no last names and were conveyed and receipted like any other farm goods of the day. By 1930, roughly 30 percent of the farmed acreage in Hanover was owned by black farmers. (Arthur and Dale Taylor.)

Commissioner's Sale of Fine
MARKETING LAND
IN THE COUNTY OF HANOVER,
For Sale at Public Auction.

By virtue of a decree of the circuit court of Hanover county, entered on the 4th day of October, 1871, in the united causes of Via vs. Via and als. and Gibson and als. vs. Via's executor and als., I will, as special commissioner appointed by said decree, offer for sale at Public Auction, on the premises, at 12 M., on

Thursday, 16th of November, 1871,

and if not sold on that day again on WEDNESDAY the 22d of November, and if not sold on that day again FRIDAY the 1st day of December, 1871, that valuable farm known as TALLEY'S, the property of the late Gilson Via, containing **230 ACRES,** more or less, situated in the Township of Henry, county of Hanover, about two miles from Haw's mill, and the same distance from Gethsemane church, and about eleven miles from Richmond, in the finest marketing region of Hanover county. This land has upon it a framed dwelling house, is well timbered and watered, and adapted to the culture of all vegetables and other crops grown in this section of country, and is convenient to mills, shops, stores, schools and churches. It will be sold in the whole tract, or in parcels to suit purchasers.

TERMS.—Cash sufficient to pay all the costs of these suits and expenses of sale (probably $150), and the residue in three equal instalments, payable in one, two and three years from day of sale, with interest at six per cent. from said day of sale, for which bonds, with good security, will be required of the purchaser, and the title retained until all of the purchase money is paid, and a conveyance directed by the court.

GEORGE P. HAW

$1225 ____ Richmond August 27th 1856
For and in Consideration of the Sum of
One Thousand Two Hundred & Twenty
five Dollars received of Hugh A Watt
I have this day Sold to him a Negro
woman named Amanda & her
Two Children named Caroline &
Nancy. which Said Slaves I warrant
Sound & healthy — I warrant & defend
the title to the Same good & free from
all incumbrance Witness my hand
& Seal the date above mentioned
S. F. Norment.

THE WATT PLOUGH.

PATENTED BY GEO. WATT,

July, 1866 and November, 1867.

Manufactured and sold by WATT & KNIGHT,

WITH AGRICULTURAL IMPLEMENTS GENERALLY.

1450 FRANKLIN STREET, RICHMOND, VA.

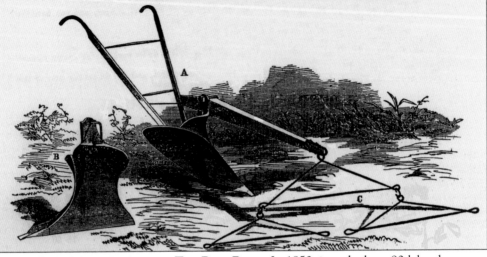

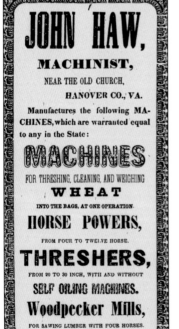
THE BEST PLOW. In 1850, it took about 90 labor-hours to produce 100 bushels (5 acres) of wheat with a walking plow, brush harrow, and hand broadcast of seed, sickle, and flail. On the Watt Plough, the mould-board, point, and slide could be renewed when worn out. Each size plough had two or more sizes and shapes of mould boards that could be put on the body to turn over the soil or to cultivate crops. These simple and cheap ploughs cost $7 in 1866 and were considered among the very best money could buy. (Arthur and Dale Taylor.)

HAW'S SHOP. Begun in the early 19th century, Haw's Shop probably had no equal in the state by the late 1850s. Just before the war, the county was truly prospering. Each farmer endeavored to have his farm fully equipped with all the machinery necessary, such as Woodpecker mills, threshers, and gristmills. John Haw, a well-respected member of the Tidewater community, provided all that a farmer needed. However, peace and prosperity were shattered in 1861. The Confederate government offered to defer military involvement because of the shop's importance, but all of the white employees of the shop volunteered for service. Haw's Shop was shut down, and the equipment was sold to the Tredegar Iron Works. (Arthur and Dale Taylor.)

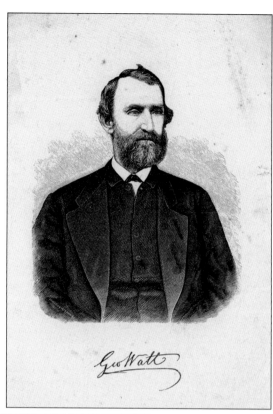

Geo Watt

"PLOWMAKER OF THE SOUTH." George Watt was born on August 11, 1815, at Springfield Farm, later to be called Watt House. He was a direct descendant of James Watt, who patented his efficient steam engine. George Watt worked in John Haw's shop as a young man. In 1842, he patented and manufactured the plows he had long tested at Springfield. In 1867, he began to sell his plows throughout the South from a Richmond base. According to his obituary, he was the original founder of the Richmond ASPCA. (Arthur and Dale Taylor.)

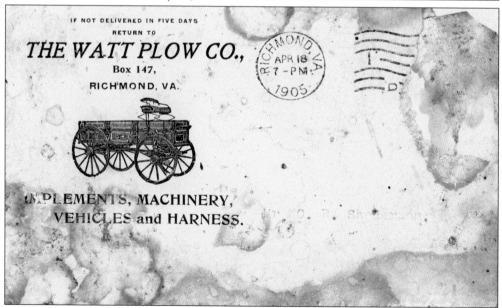

IF NOT DELIVERED IN FIVE DAYS
RETURN TO
THE WATT PLOW CO.,
Box 147,
RICHMOND, VA.

RICHMOND, VA
APR 18
7 - PM
1905

IMPLEMENTS, MACHINERY,
VEHICLES and HARNESS.

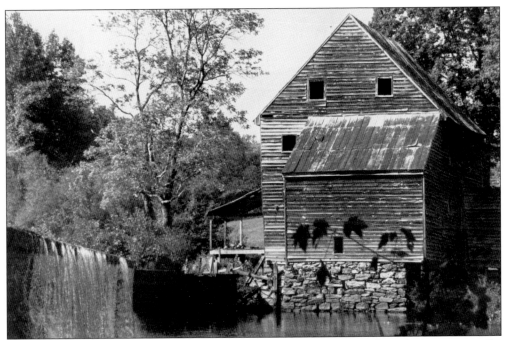

MILLS OF HANOVER COUNTY. Mills fell into two classes: custom mills and plantation mills. The custom mills, like Ashland Roller Mills or Newman's Mill, served the public, while plantation mills were made to furnish the flour and meal for the plantation on which they stood. Most of the mills have vanished with advances in technology and transportation, but photographs of Woodson's Mill (above) and Beattie's mill (below) conjure the romance of an overshot wheel churning a lazy stream. (*Herald-Progress.*)

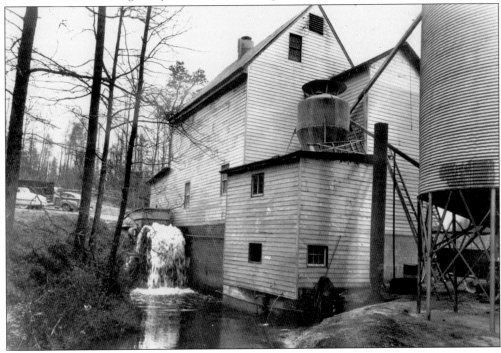

FULCHER'S MILL. Fulcher's Mill, thought to have been connected with Oakland, is a fine example of a plantation mill that was still operating in 1950.

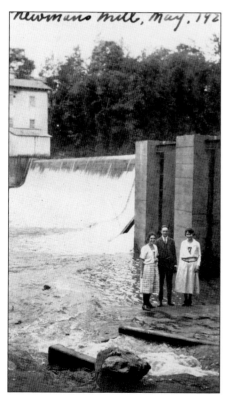

THE HOME OF PATRICK HENRY FLOUR. One of the oldest mill sites in the county is Ashland Roller Mills on the South Anna River. Originally known as Darracott's Mill, it was bought by W.W. Newman in 1872. During the devastation of the Johnstown Flood in 1889, the mill was washed away, yet the mill dam remained. The mill was rebuilt in 1892. Newman's son, E.W., became the owner of the mill and president of the Piedmont Miller's Association. (*Herald-Progress.*)

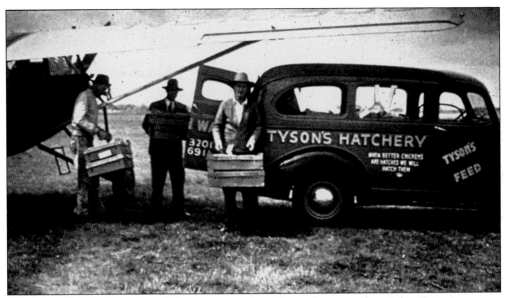

TYSON STARTS IN MIDWEST. These pictures show the early years when John Tyson's start-up business made poultry deliveries in the Midwest. Over time, his company would revolutionize the poultry industry. When shortages of baby chicks threatened his trucking business, John bought a hatchery. When he couldn't get the feed he needed, he started a commercial feed business, grinding and mixing his own. By the end of the 20th century, Tysons was one of the top 10 employers in Hanover County. (Tysons Foods.)

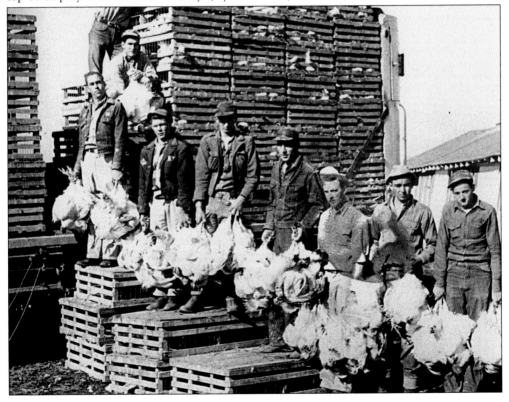

SELF-SUFFICIENCY. Most farmers raised their own chickens for eggs and Sunday dinner and a few cows in the pasture for fresh milk, cream, butter, and cheese and manure for fertilizer. Each year, new calves provided cash at local markets or meat for the family when they had been raised. (Dorothy Jones.)

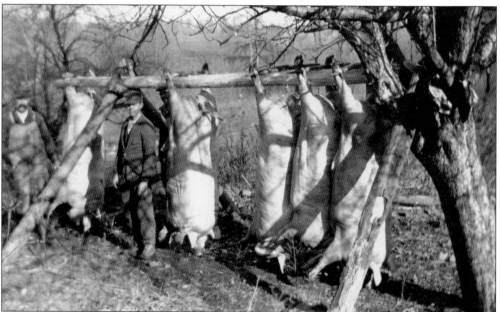

HOG: PART OF THE CULTURE. Hog butchering was done in the fall when the weather was cold and crisp. Most farmers did the operation themselves, but Elizabeth Bowles Gayle of Oakley Hill remembered people who traveled from farm to farm to help: "Aunt Nannie Roane was quite well known throughout the community. She would help cut up the fat. Also working along cutting the fat and the lean meat for the sausage was Luther Bosher. Mother always wanted him to come because he was so neat and particular. The fat and the lard was strained and put in big tins and put down in the cold ('spring') house. The hams and bacon were cured."

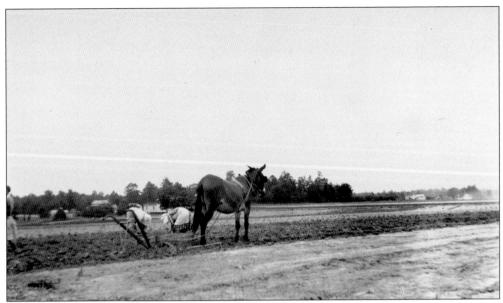

TRUCK FARMING IN LOWER HANOVER. According to the 1930 census, around the time when this picture was taken, about 17,000 people lived within the 512 square miles of Hanover County. The population density was 33.2 inhabitants per square mile, decidedly below the average of 57.4 for the whole state. Ashland, the largest concentration of population in the county, had 1,297 people living within its borders. The greatest proportion of the people lived on farms or in open country. Here, two women tend a broad, flat, Lower Hanover field. (Dorothy Jones.)

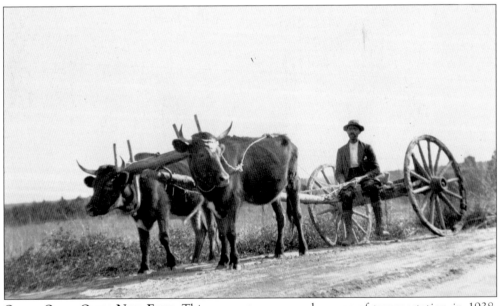

OLLIE, OLLIE OXEN NOT FREE. This was not an unusual means of transportation in 1938. (Dorothy Jones.)

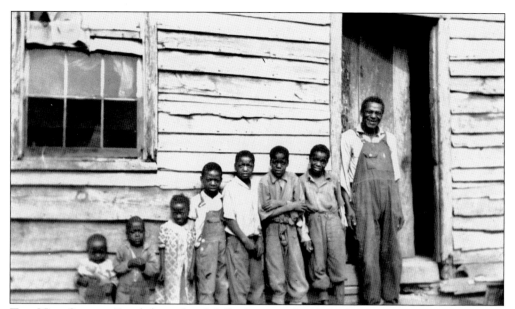

THE NEW SOUTH. Freed slaves faced difficult times. In 1840, there were 2,444 more African Americans than whites in Hanover County. By 1930, when this picture was taken, there was a majority of 4,475 whites. After the Civil War, when families were set free to settle in places of their own choice, many families left for the North, where they believed there were greater opportunities in industrial cities. Those who stayed faced the difficulties of illiteracy, poor housing, and a society that remained segregated. (Dorothy Jones.)

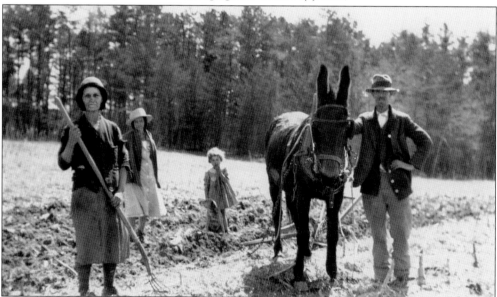

SHARECROPPING AS A WAY OF LIFE. Of the 2,671 farms in Hanover County in 1938, tenants operated only 333. Of this number, 149 were cash tenants and 184 sharecroppers. Yet, the overall situation for farmers was not wholly satisfactory. Relatively little property and relatively low income was the lot of not only the tenant and wage earner but also a large percentage of farm owners. Forty-one percent of the farm operators in the county had a gross income of less than $600 per year.

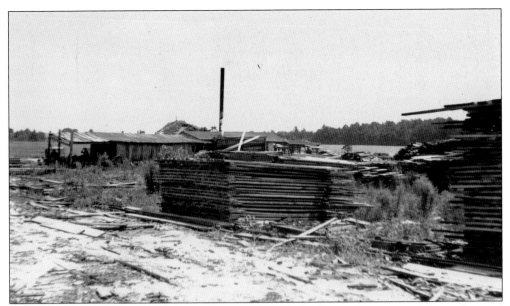

OLD PLANING MILL. Montpelier remains, as it has always been, the center of the timber and grain industry in Hanover County. Hear the splitting crash of falling trees, the noise of the "snakers" as they haul the fallen trees to the sawmill, and the hum and whir of the saw as the lumber is cut by the blades in the mill. Even today, almost every truck loaded with timber seems to be headed from the western part of the county. (Dorothy Jones.)

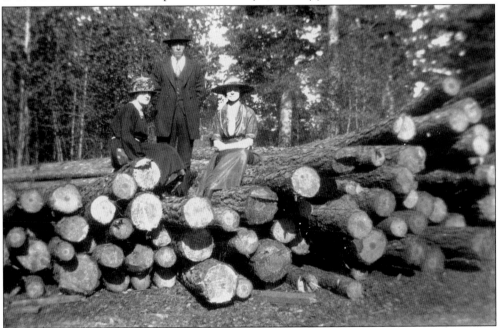

READY FOR MILLING. Pine, oak, and gum were and are the main timber resources of Hanover. Pine is the most prevalent. Sawmill operations averaged 21 men to a mill who divided their forces into two groups—the woods force and the sawmill force. The wood cutters enter the forest and fell the trees to be followed by the loggers and the snakers, who pile the logs. (Edith Sagle Jones.)

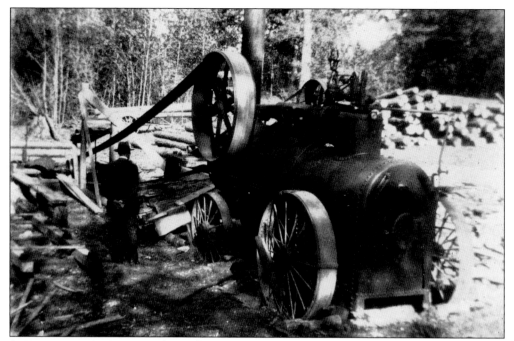

STEAM-POWERED PLANT. The mill force includes sawyers, firemen, lumber carriers, truck drivers, and others who assisted in the manufacture of lumber. All earned wages that fed (and still feed) the general economy of the county. Here at a Jones mill, a steam-driven engine powers the plant. (Edith Sagle Jones.)

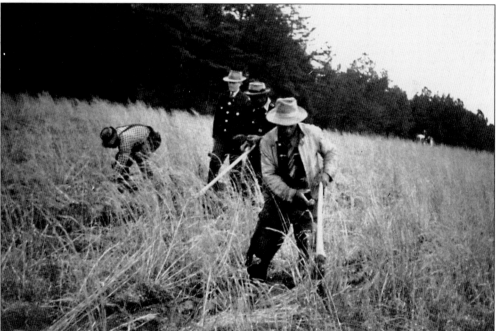

REFORESTATION. After large stands of timber are "logged off," the tracts must be replanted with seedlings for harvest in later years. Mills are moved to a new location of trees ready to be felled. (Edith Sagle Jones.)

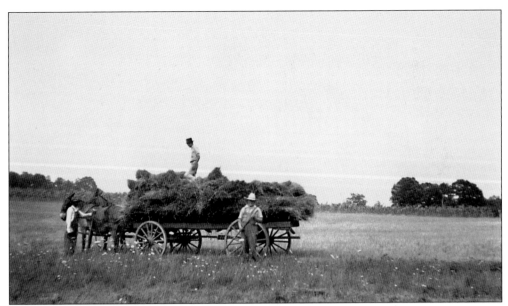

TOBACCO, WHEAT, AND CEREAL GRAINS. The upper part of Hanover is known for its wheat and cereal grains and tobacco. Tobacco soils are usually light clay loam for heavy tobacco and light or sandy loam for light or cigarette tobacco. Rotations for tobacco are usually in the following order: corn, followed by a green winter crop such as crimson clover, then tobacco, followed by wheat. Although tobacco was probably one of the very first crops harvested in the county, its production waned over the years because of soaring production costs and diseases such as "Blue Mold" and "leaf firing." (Dorothy Jones.)

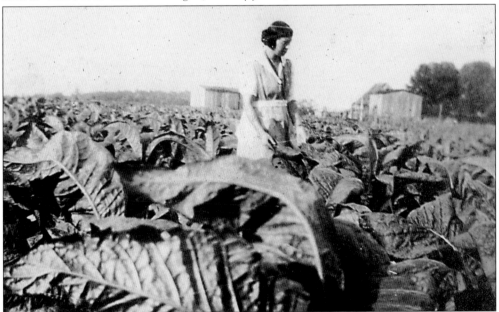

SUN-CURED TOBACCO. In the 1930s, Montpelier, Beaverdam, and Rockville still produced cash tobacco crops. At least 500 acres were still in cultivation, producing sun- or air-cured tobacco. The chief variety grown in Hanover was Oronoco. There was a small amount of Burley tobacco that was abandoned for lack of market. (Edith Sagle Jones.)

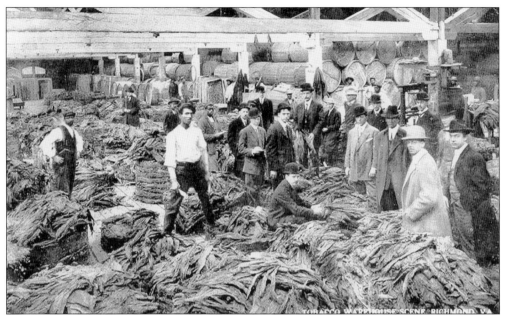

BUYING TOBACCO. All of the tobacco produced in Upper Hanover was destined for the Richmond Tobacco Markets where the major cigarette companies sent their buyers. (VCU Library.)

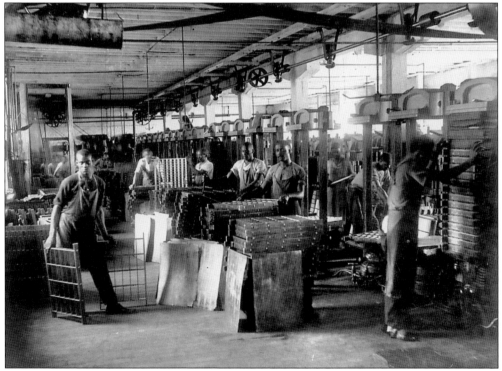

RICHMOND MARKET DESTINATION. Nearly all of the tobacco produced in Upper Hanover was destined for such Richmond markets as T.B. Williams Tobacco Company, pictured here. (Library of Congress.)

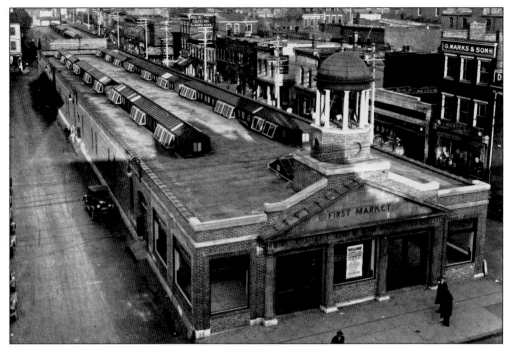

SEVENTEENTH STREET MARKET. Truck farming is chiefly the characteristic of Lower Hanover. In the 1920s and 1930s, the average size of a truck farm was about 25 acres of tillable land. Every acre of land grew several different crops at different times of the year. The major crops were early tomatoes (especially in "Florida Town"), sweet potatoes, cantaloupes, onions, salads, market corn, snap beans, butterbeans, strawberries, asparagus, beets, carrots, watermelons, cabbage, squash, turnips, cucumbers, black-eyed peas, and "Irish" potatoes. Nearly all the produce was taken in Hanover Wagons, like the ones pictured below, to the Richmond Seventeenth and Sixth Street Markets. (Dementi Studios.)

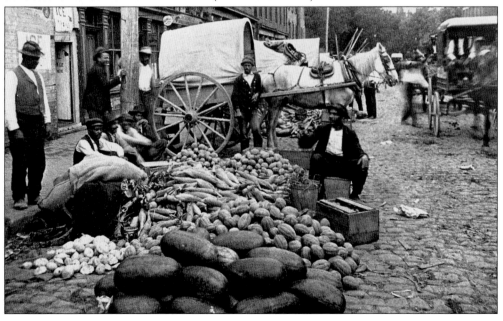

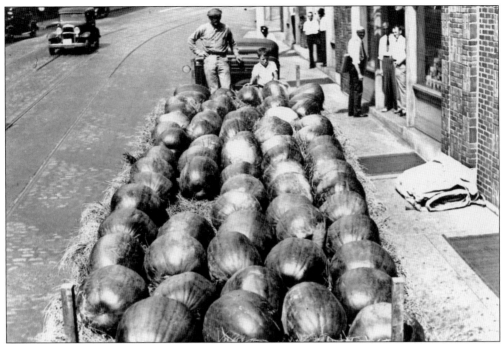

MELONS: THE ORIGINAL HANOVER TREASURE. Watermelons from Hanover County were considered the very best. As slow-moving, mule-driven carts plied the streets of Richmond, Hanover farmers could be heard crying, "Water millions! Fresh from Hanover! Cantaloupe, lope, lope, lida lope, lida lope!" (Dementi Studios.)

NOW IT'S TOMATOES. Melons and cantaloupes have been supplanted by tomatoes. At the end of July, the Hanover tomatoes make their appearance at local produce stands, and the Tomato Festival gets underway. Local farmers have learned, however, that markets for these amazing fruits are not limited to Hanover County. They are becoming famous all the way to New York. True natives know how to make the kind of tomato sandwich with white bread that "you have to lift and eat fast lest it fall through the crust," as Brother Dave Gardner used to say. (*Herald-Progress.*)

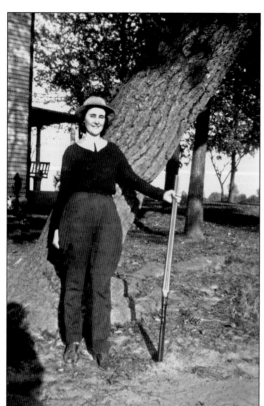

BIRD HUNTING. Lillian Moody Duke enjoyed skeet shooting with her father and brother. (Lillian Moody Duke.)

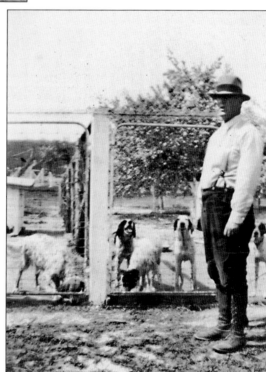

MELVIN BRUCE MOODY SR. This gentleman was a boarder and trainer of bird dogs in the 1920s and 1930s. (Lillian Moody Duke.)

FAMILY SITTING ON FORD.
Emma Jane Goodman Hall and
Benjamin Warren Hall sit on
the back of their 1942 Ford.
Alice Hall Murphy, who saved
up for a mail-order Kodak
camera, probably took this
"snap" with her new camera.
(Art and Dale Taylor.)

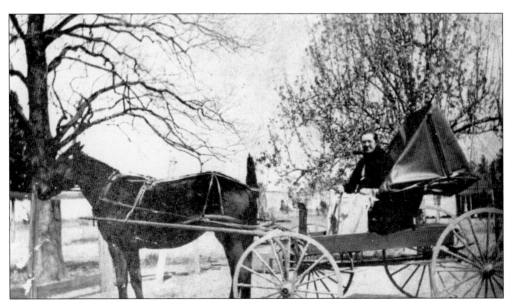

FAMILY DRIVING WAGON. Before Fords and macadam roads, this was the preferred method of travel along Hanover roads. (Gethsemane Church Record.)

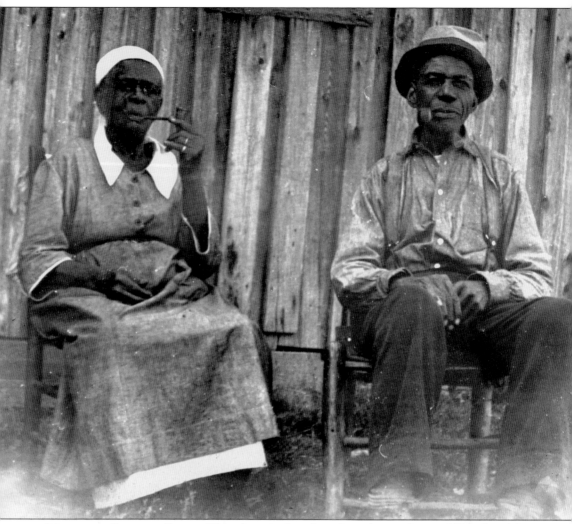

MOSES AND JOEANNA PRYOR. This photo is thought to have been taken in 1938 when Moses Pryor would have been around 88 years old. Moses died at 103 in 1953. According to their granddaughter, Ethel Buggs, her grandparents, who were born to slaves in Montpelier, were "happy loving people who always kept a garden. My grandmother smoked a pipe and made the best stewed chicken and rice, cabbage and ham hocks, fried chicken and candied sweet potatoes. My grandfather was not educated but he taught himself to read. He never needed glasses. He had apple, pear and peach orchards and good wine." (Dorothy Jones.)

Five

FRIENDS AND NEIGHBORS

BUILDING PINE KNOB. Working together to build Pine Knob one-half mile west of Gethsemane Church are, from left to right, unidentified; Aubrey Nolan Atkinson; Macon Atkinson; Aubrey Hay Atkinson, brother to Macon; Hartwell Abel Adams; and Edward Broaddus Bowles. (Wesley Smith.)

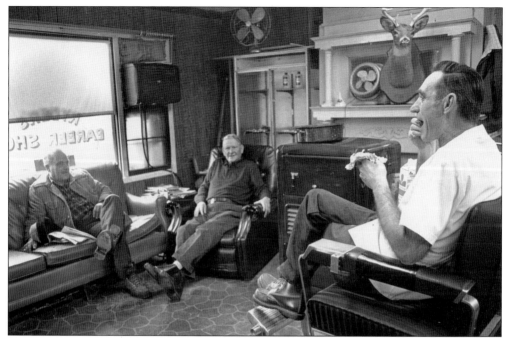

RYDER'S BARBER SHOP. Sam Glass (left) and Jim Butler (center) sit in the worn, soft chairs in Ryder's Barber Shop next to the stove, for conversation with proprietor Jim Ryder (right). (*Herald-Progress.*)

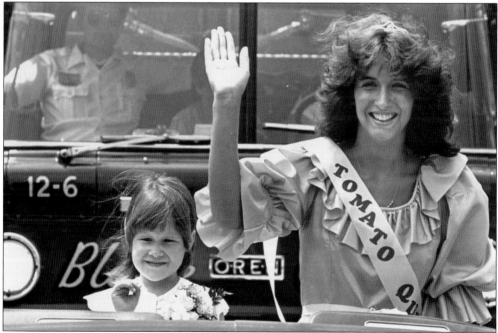

TOMATO QUEEN. Why have a parade if there isn't a queen to wave at the crowd? Hanover was traditionally known for its melons. By 1977, however, the Hanover tomato had become the star of produce stands. Here at the seventh annual festival at Black Creek in 1984, Doug Buerlein captured Tamara Burkett doing the queen's wave. Sarah Blake emulates her. (Doug Buerlein.)

GOING! GOING! . . . Borkey's Store and Antique Auction was well known in eastern Hanover County. Mr. Borkey is at the microphone in the late 1970s. (Photo by Nancy Andrews.)

PEAKS. Miss Elsie Dyson was born in Peaks in 1899. By her admission, Peaks has always been a small, sleepy community. "For fun on Sundays, we'd wait for the train to stall, coming up the hill back there. Then we'd all run over and sit on the hill and watch them split the train in sections and pull it up to the depot, a section at a time." (Doug Buerlein.)

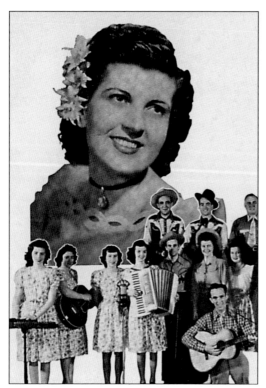

"Sunshine Sue." Richmond radio station WRVA's Old Dominion Barn Dance (1947–1957) was so successful locally that it was syndicated nationally over the networks. The country music variety show featured "Femcee" Mary Higdon "Sunshine Sue" Workman and her husband, John Workman, as hosts. Among its performers were the Carter Sisters, Grampa Jones and Ramona, the Tobacco Tags, Chet Atkins, and Earl Scruggs. The Workmans lived at Medley Grove Farm, now Brookmeade Sod Farm, in the Ashland area. (Paul Vidal.)

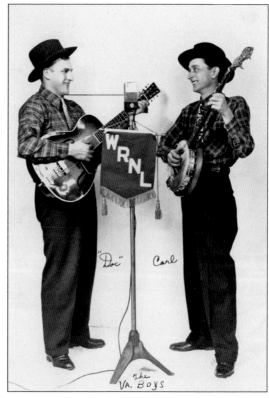

The Virginia Boys. The Virginia Boys performed at Montpelier High School in the 1940s and 1950s. (Edith Sagle Jones.)

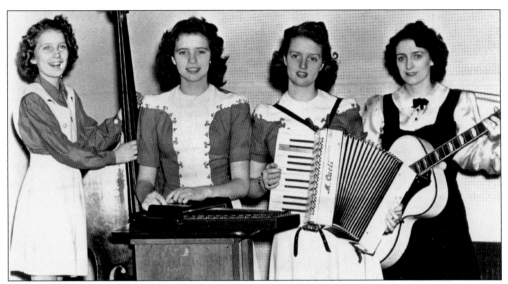

JOHNNY CASH'S WIFE, JUNE CARTER. The original Carter Family band broke up in 1936 but the Carter sisters—Anita, June, and Helen—and their mother, Maybelle Carter, continued the tradition. This Virginia-born family was heard across the country, having made their first recording in 1927. They performed to a packed house in Montpelier in the 1950s. The Carters were often a staple on the Old Dominion Barn Dance, accompanied by their guitarist, a young Chester Atkins. (Edith Sagle Jones.)

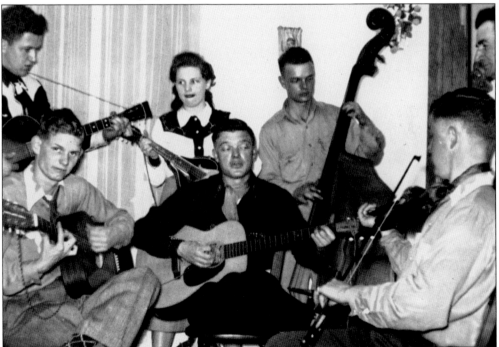

FAMILY BAND. Many families created their own music at home. From left to right are (sitting) Ervin Lee, Jacob Shiflett, and Churchill Lee (with fiddle); (standing, in the back) Lowell T. Talley, Jean Lee, Bill Shiflett (with base), and Bill Weis, partially cut off. Called the Atlee Ramblers, this band favored country and rockabilly music. (Sandra Talley.)

THE CAMPTOWN RACES

TWENTY-THIRD RUNNING

*A Country Race Meet
to be run at*

THE CAMPTOWN COURSE

MANHEIM FARM

Ashland, Virginia

**SATURDAY, MAY 8, 1976
2:00 P.M.**

Benefit
Ashland War Memorial Association
and Local Civic Projects

PROGRAMS FIFTY CENTS EACH

CAMPTOWN WINNER'S CIRCLE. The races at Camptown, begun at The Meadow in Caroline County, continued for six years, skipped a year, and then moved to Manheim Farm just north of Ashland at a site leased by the Camptown Committee from S.D. Quarles and J.R. Gilman, owners of the property. Racing proceeds, sometimes over $30,000, all went to benefit the Ashland War Memorial, Hanover Art and Activities Center, Ashland Volunteer Fire Company, Ashland Rescue Squad, Ashland Jaycees, and Patrick Henry FFA. (*Herald-Progress.*)

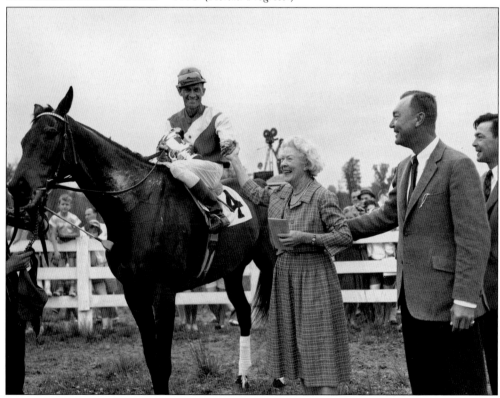

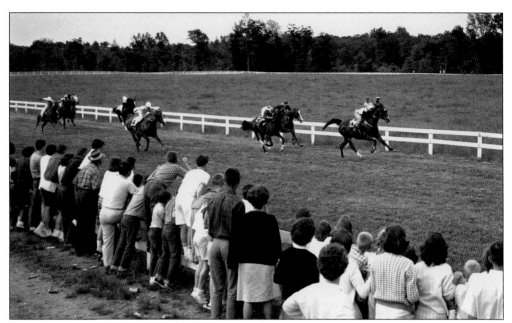

HORSE RACING IS NOT NEW TO HANOVER. Camptown put Hanover on the entertainment map on the East Coast in 1953, but horse racing is not new to the area. There is evidence that the sport was an active pastime in Colonial Williamsburg just a few miles east. Major Doswell's "Bullfield" was a prominent sporting establishment, as was the Ashland racetrack in central Ashland. (*Herald-Progress.*)

THE FIRST RACE. The first race was in June 1953 at The Meadow, the estate of horse-raiser Christopher Chenery just across the river in Caroline County. The event was a fund-raiser for the Ashland War Memorial, and Edmund DeJarnette's predictions for a 3,500-person turnout were realized. The races are being run again in Hanover County after a long hiatus. (*Herald-Progress.*)

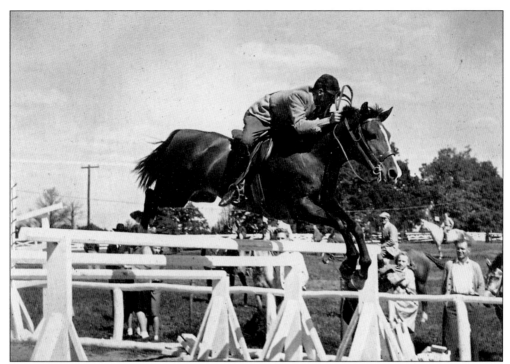

NOT EVERYONE COULD DO THIS. Tom Holloway and his mount "Boots" execute the difficult triple bar jump at Deep Run Hunt Club in the 1950s. (Edith Sagle Jones.)

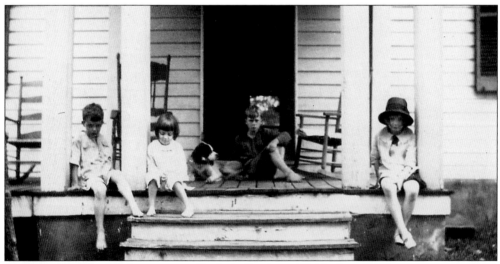

SUMMERTIME. The McGuires are at Taylor's Creek in 1924 before renovations were made to the home. On the left is Jim McGuire, killed during World War II, and his sister, Virginia Armistead McGuire, who became Mrs. Andrew Jackson Brent. The boy sitting beside the contented dog is unidentified. On the far right is Elizabeth Marshall McGuire (Mrs. George Williams.) What signifies summer more than bare feet, a wide front porch with rocking chairs, and a dog to chase after a rest? (Anne Nelson.)

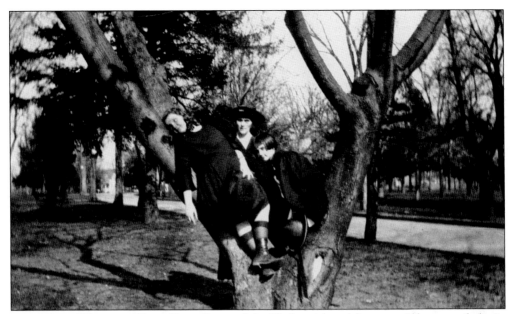

GIRLS JUST WANT TO HAVE FUN. Some of the Taylor girls at Maymont Arboretum frolic in the limbs of an old tree sometime in the late 1920s. (Caroline Cherry.)

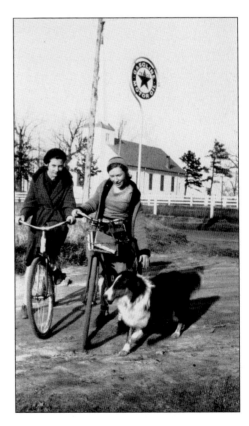

TOURING. A couple of fashionable Montpelier girls with bikes stop at a Texaco sign in front of the Church of Our Saviour to pose with their collie. (Edith Sagle Jones.)

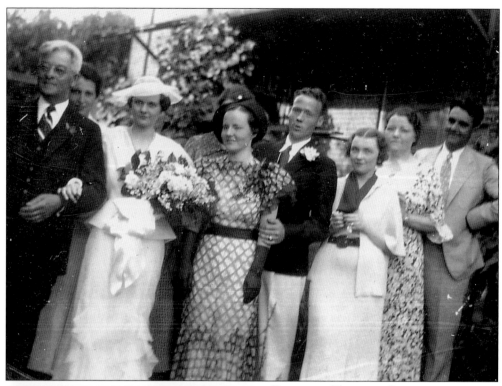

READY TO TOSS THE BOUQUET.
Weddings were always an opportunity for
friends and families of neighboring farms
to get together to celebrate and show off
fashions of the day. (Caroline Cherry.)

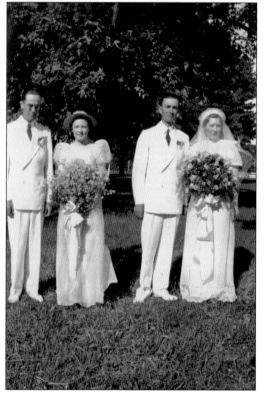

LEATHERBURY WEDDING. The wedding of
Rebecca Leatherbury and Herman Boyd
Jones is seen here with attendants in 1937.
Ms. Leatherbury was a home economics
teacher at Montpelier High School, but
her classes were held inside the ancient
Sycamore Tavern. (Edith Sagle Jones.)

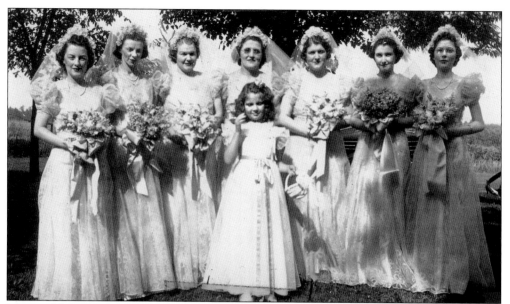

MOODY-MORRIS WEDDING. The bridesmaids are pictured at the July 6, 1940 wedding of Barbara Noel Moody. This photo was taken at Traveler's Rest after the wedding at Shiloh Methodist Church. From left to right are Eleanor Harrison, Alpine Beazley, Virginia Rose Moody, Margaret Isbell, Elizabeth Moody, Lillian Moody, and Annie Mae Morris. The flower girl is Patricia Wilkerson. (Barbara Jones.)

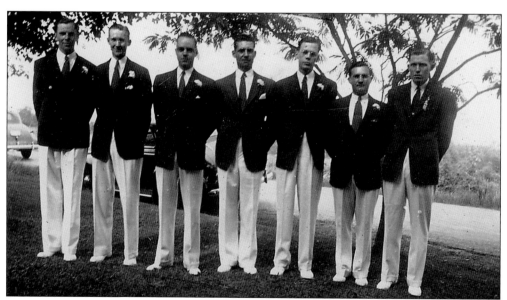

GROOMSMEN. From left to right are Wesley Wallinger, Charles Durham, Gordon Swinford, Andrew L. Duke, William Jeter, Melvin Bruce Moody Jr., and Franklin C. Morris. (Barbara Jones.)

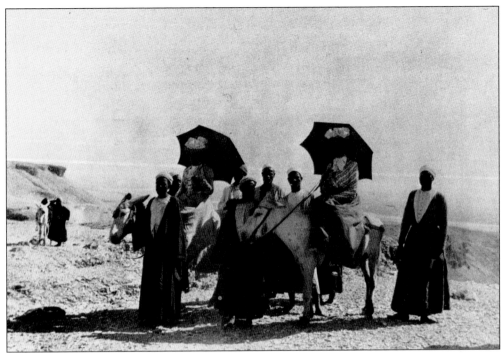

EXOTIC TRAVEL. Helen Aldie Lathrop and Florence Lathrop Page are visiting Kaab around the turn of the century. One can only imagine enduring the stifling heat in those long dresses. (University of Virginia Library.)

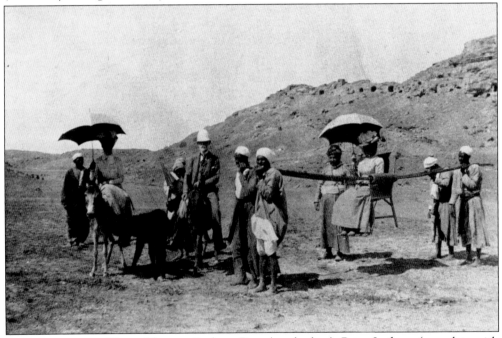

GETTING AROUND KAAB. Florence Lathrop Page (on donkey), Brian Lathrop (complete with pith helmet), and Helen Aldie Lathrop (borne along in chair) are depicted during another phase of their travels in Kaab. (University of Virginia Library.)

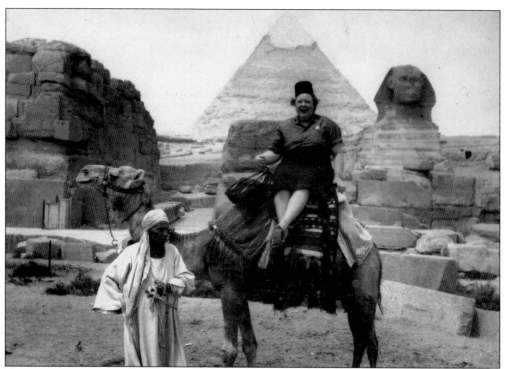

LA TOURISTA. Everyone of a certain age will recognize Sis Cross on camelback in Egypt wearing her fez. (Tom Willis.)

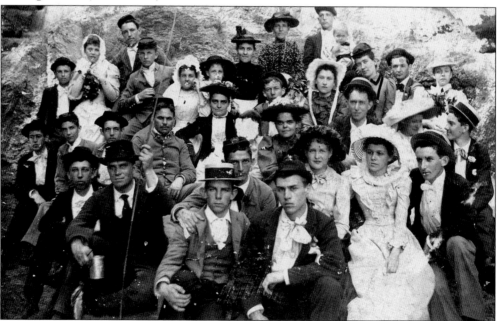

CLOSER TO HOME. Though not as far or as exotic as Egypt, Auburn, Alabama, attracted Susan Rose Pleasants (wearing the white bonnet with long ribbons, upper right) sometime around the turn of the century. It is sad that we cannot identify all the people in the picture, but many who have seen it spend a long time studying each person's remarkable outfit. (Anne Nelson.)

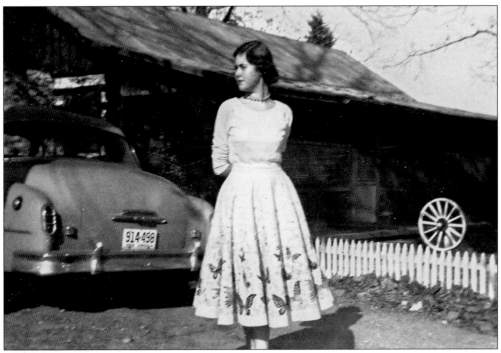

FASHION MODEL. Barbara Bruce Duke Jones strikes a pose in her butterfly skirt beside the family's 1950s car.

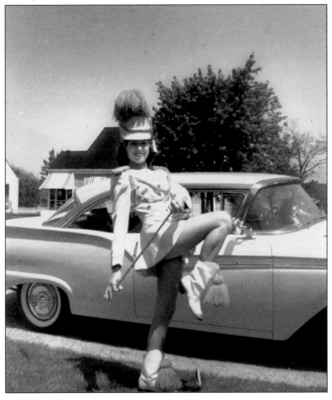

MAJORETTE. Many girls longed for a pair of boots with tassels and a plumed hat, like Betty J. Tate is wearing sometime in the mid-1950s. (Sandra Talley.)

BRITISH SOLDIERS IN MONTPELIER. During World War II, English sailors stationed at Norfolk were invited to stay at local farms for a little rest and relaxation. Local families welcomed the boys to work and play in the community. (Edith Sagle Jones.)

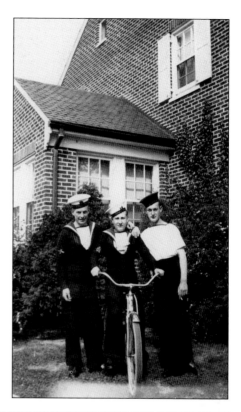

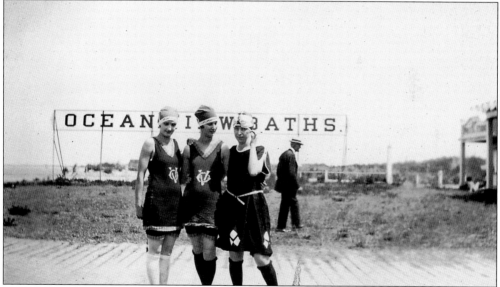

GOING TO THE BEACH. Church groups and families often took the train to Buckroe Beach, and many went over to Ocean View on the boat. One longtime resident remembers how "we'd plan the trip for weeks and all the young girls felt they had to have new sport dresses . . . linen with a little pleated skirt and a simple little collar. Lois Wickham remembers that their hired man went with them one time and lost his teeth on the Dippity Dip Roller Coaster." (Edith Sagle Jones.)

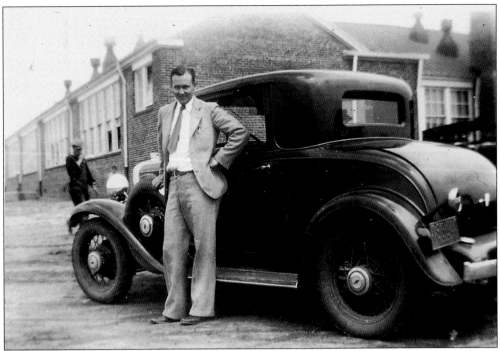

PRINCIPAL DURHAM. R. Watson Durham was the first principal at Montpelier High School. Here, he stands in front of his automobile. (Edith Sagle Jones.)

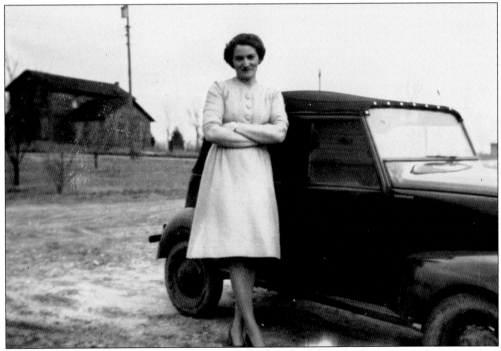

LOIS LATHROP WICKHAM JONES. Lois Lathrop Wickham Jones stands beside her cherished new car in her side yard with a view of Woodman Hall in the background. Born in 1910, Mrs. Jones died in 1998. (Edith Sagle Jones.)

WEDDING DAY. Lillian L. Moody and L. Andrew Duke are seen here on June 17, 1939. The couple recently celebrated their 65th wedding anniversary. (Lillian Moody Duke.)

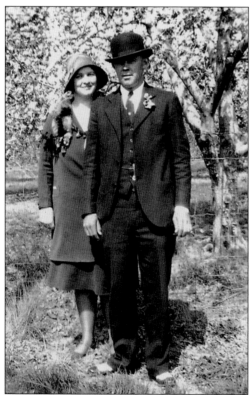

BEST FASHION. This couple demonstrates what a well-dressed pair might wear in the 1930s.

PROF. CHARLES MORRIS. Prof. Charles Morris ran a school for boys at Taylor's Creek from 1865 to 1868. Morris was a professor at Randolph-Macon College, the College of William and Mary, and the University of Georgia. He also served as the Commonwealth's attorney for Hanover County. (Anne Nelson.)

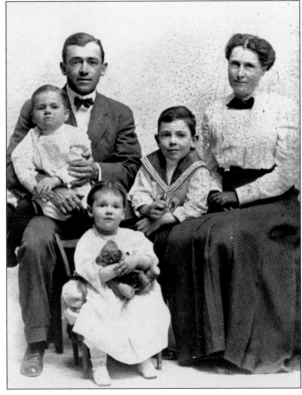

THE NELSON FAMILY. Shown here are Dr. John Peyton Garnett Nelson and his wife, Susan Rose Pleasants Morris, of Taylor's Creek. In Dr. Nelson's lap is Charles Morris Nelson; between his parents is Kinloch Nelson, for whom the Nelson Clinic at Medical College of Virginia is named; and the baby with the bear is Louise Bolling Nelson (Mrs. William Hugh Redd). The photo was taken sometime around 1911. (Anne Nelson.)

NANCY RISELY ANDERSON (WRIGHT).
Nancy Risely Anderson (Wright) was
the daughter of Robert Anderson of Hill
Fork in eastern Hanover County. Nancy
married Gustavus Wright, who served in
the Hanover Grays. Letters written
between the couple during the Civil
War are family treasures. Mr. Wright
served as postmaster in Old Church for
several years. This charcoal drawing
dates to about 1860. (Dale Talley.)

**MARY DEARBORN WRIGHT
(HIGGASON).** Mary Dearborn Wright
(Higgason) is the daughter of Nancy
Risely Anderson (above). This
photograph in 1912 shows children
Edward Charles Higgason and Maude
Carol Higgason. The family lived in Old
Church. (Dale Talley.)

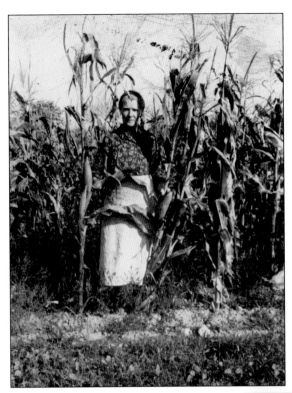

WORKING HARD. Ruth Hall was one of nine children born to Horace and Rosa Hall. This picture was taken in the 1940s. (Art and Dale Taylor.)

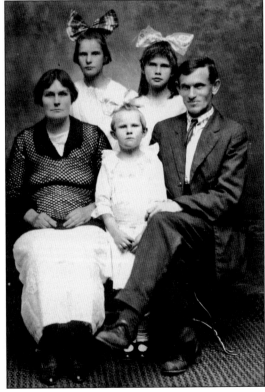

THE HALL FAMILY. Emma Jane Goodman Hall and her husband Benjamin Warren Hall are pictured with their family. The baby is Minnie Lee Hall. Standing to the left is Annie Jane Hall, and on the right is Alice Christmas Hall. (Art and Dale Taylor.)

90

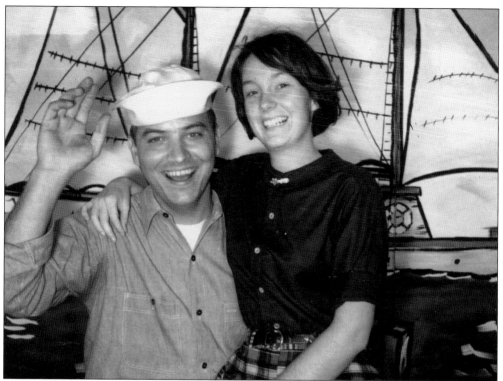

SAILOR BOB. Anyone who lived within the broadcast radius of WRVA-TV (Channel 12) in the 1950s and 1960s will remember Sailor Bob (Bob Griggs) and his pal, Gilly Gull, who greeted children every day and made them laugh. He urged kids to eat Noldes Bread, which sported the bright blue wrapper. Here is Caroline Cherry, of Caroline's Thread and Canvas, in her madras shorts and Villager blouse having a moment with everyone's favorite sailor. (Caroline Cherry.)

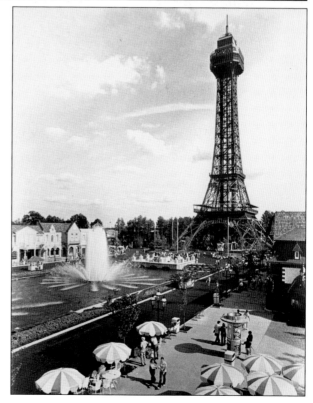

KING'S DOMINION. King's Dominion opened its doors in the mid-1970s in the northern part of Hanover County along Interstate 95. Famous for its Rebel Yell roller coaster and replica of La Tour Eiffel, the park draws countless children and their weary parents each year. (*Herald-Progress.*)

THE MENACE OF HANOVER COUNTY. Mary Louisa Bolling Morris was born in 1870 at Taylor's Creek. From 1914 until 1955, she worked the farm herself and grew violets to sell. Anne Nelson, who lives at Taylor's Creek, leaves all violets where they grow in her memory. A nephew remembers: "She was a cantankerous old soul who drove Model T Fords though she never learned how. She was the menace of Hanover County. It was the big joke. . . 'Look out! Here comes Miss Louise on the wrong side of the road!' " (Anne Nelson.)

Six

SCHOOLS

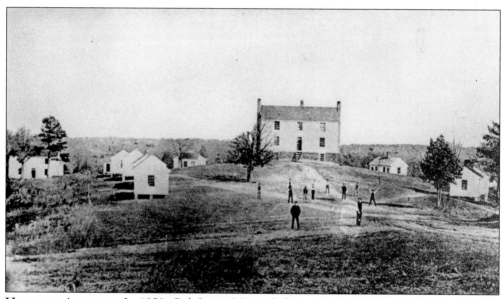

HANOVER ACADEMY. In 1859, Col. Lewis Minor Coleman opened Hanover Academy on the Jones estate within a mile of Fork Church. Begun to prepare boys for the University of Virginia, it became known as the "Rugby of the South." The school brochure read: "The sessions commence annually on the first of October and terminate on the last of July following. The subjects taught are divided into three sections viz: Ancient Languages, Modern Languages and Mathematics. The terms for the session of ten months for tuition, washing, board, bedding—in short everything except lights which are furnished by the student—are $200." Military drills were also a part of the curriculum; girls from nearby Cherrydale often watched. During the Civil War, most of the boys enlisted. At war's end, Hilary P. Jones and his brother Horace bought out Colonel Coleman's interest. The academy turned out many prominent scholars, such as Thomas Nelson Page, Rosewell Page, Judge Lawrence Groner, James Gordon Battle, S.J. Dosewll, and Adm. Hilary Jones, whose portrait hangs at Hanover Courthouse. Nearby Fork Church students' initials, names, and dates can be seen neatly carved in the pine of the back of pews. (*Herald-Progress.*)

HALL'S FREE SCHOOL. Land and the sum of $4,000 were left in the late Aaron Hall's will to establish a school for his "poor neighbors" in the community. It was run by a self-perpetuating board of trustees of men picked from the neighborhood families. Its endowment was increased by donations from the wills of Thomas Nelson Page and Marcellus Eddleton. Serving on the board is an honor, and the surviving members, in case one dies, usually try to appoint a board member's descendant. The school does not operate today, but the board still invests extant funds to award scholarships. (*Herald-Progress.*)

WASHINGTON AND HENRY ACADEMY. Established sometime during the Revolution around 1778, this is the oldest public school still operating in the commonwealth. According to the *Herald-Progress*, this photograph was taken by Huestis Pratt Cook before the Civil War. Subscriptions were circulated to raise the required funds for the school's operation. Charles and Mary Allen sold 517 acres for £1,551 on which the school was built. At first, the school was a boarding school for boys, but by 1812, girls were in attendance. By 1905, the school was transferred to the County. (*Herald-Progress.*)

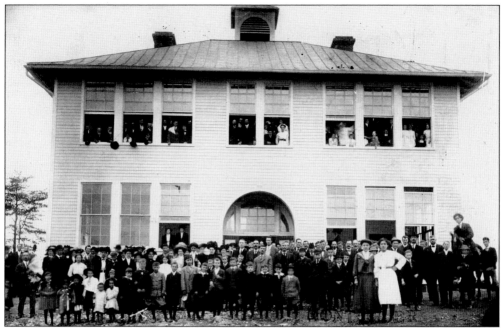

MONTPELIER HIGH SCHOOL. This is Montpelier High School sometime before 1927, when the school was razed by fire. Classes were moved to nearby Clazemont until a new school could be built. Dorothy Chewning remembered: "The old school was back off Rt. 33 about a quarter of a mile. . . . It was two stories and they just had added an auditorium on the back and we just thought it was wonderful. We had a new principal and he had just started fire drills, thank goodness." The fire began during school hours, but no one was hurt. (Edith Sagle Jones.)

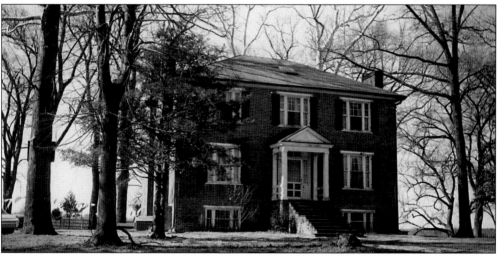

ELLINGTON. It was the custom in well-to-do early Virginia families to have a governess or a tutor to come into the home and educate the children. Sometimes small buildings would be constructed on the property for this, and neighborhood children would also attend. One such school was Humanity Hall near Hewlett, which boasted plastered walls with hand-hewn slates. Courtland, Woodland, Beaver Dam, and Hickory Hill all had small schools, as did Bear Island, Glencairn, Edgewood, Taylor's Creek, Mount Air, Meadow Farm, and Ellington. (*Herald-Progress.*)

BEAVERDAM SCHOOL. Beaverdam School is shown here in the early 1940s, when both elementary and high schools and brick and frame buildings were on the same site. (*Herald-Progress.*)

ROCKVILLE ELEMENTARY SCHOOL. From 1906 until 1945, the old one- and two-room schools decreased in number by consolidation and new construction in central locations. Even this substantial school has since been replaced by a more modern structure. (*Herald-Progress.*)

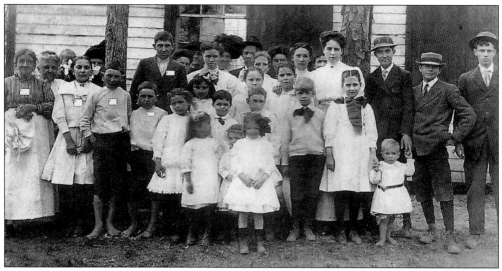

NEGROFOOT SCHOOL. In this photo taken not long after the turn of the century, only a few of the students and teachers can be identified. No one on the front row is identified. Pictured from left to right are (second row) Clarinda Washington Hedrick, unidentified, Ada West, Otis Brown, Fred Brown, Ruth Stanley, Walter Grieg, unidentified, Ashley Bumpass, Edith Wingfield, and baby Robert Hall; (third row) unidentified, Johnny Brown, Hattie Stanley, Belle Mills, Lucy Mills, E. Wingfield, Willie Bowles, Claude Wingfield, and ? Walsh; (fourth row) unidentified, Maggie Brown, Naomi Mill, and Myrtle Bowles; (fifth row) unidentified, Annie Lois Wingfield, Jim Wingfield, unidentified, and Mrs. ? Hedrick. (Florence Page Memorial Library.)

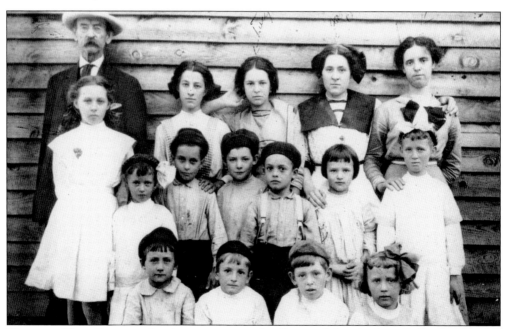

HICKORY HILL SCHOOL. In this one-room schoolhouse, John Andrew Duke Sr. presided over the education of a wide range of students. Duke was born in 1849 and died in 1946. (Edith Sagle Jones.)

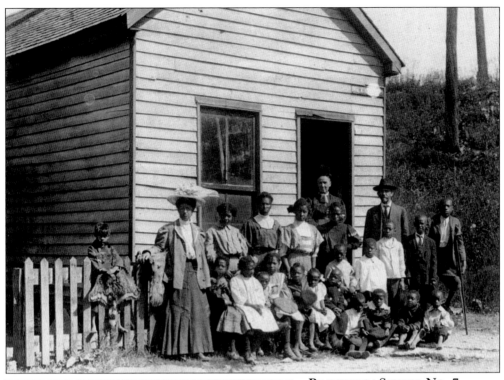

BEAVERDAM SCHOOL NO. 7.
Louise Pryor, who taught in
Hanover County, remembers: "I
had to walk to school; that was a
mile going and a mile coming every
day. The [white] school bus would
pass right by you and wouldn't pick
you up. . . . It was a segregated
school system." The tall woman in
the doorway of Beaverdam School
No. 7 is Amelia Wilkes Coates,
who often taught at the school from
March through May. (Hanover
County Black Heritage Society.)

JACK OF ALL TRADES. A teacher's
contract specified the terms of her
employment, which included the
supervision of the construction of
an outdoor privy for use of the
school. This set of specifications
details the exact process. These
teachers were only paid $20 per
month to take on the role of
caretaker, nurse, educator, and,
apparently, construction engineer.
(Sycamore Tavern.)

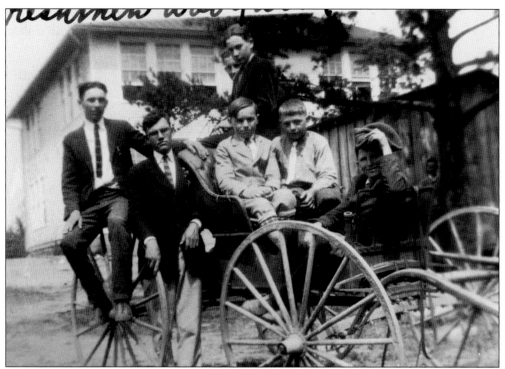

Shop and Home Economics. Life skills classes were gender specific for generations. Above is the boy's freshman woodworking class in the 1920s at Montpelier High School. Below, young girls in their bright pinafores are attending cooking class. (Edith Sagle Jones.)

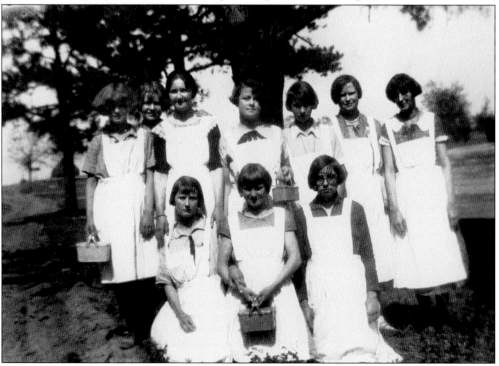

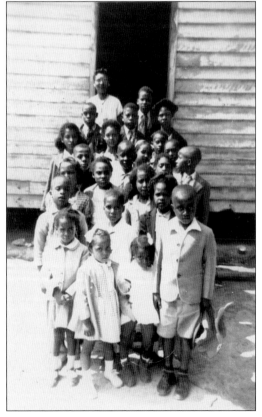

CALVARY EPISCOPAL SCHOOL. Calvary Episcopal School was founded by the Episcopal Diocese of Virginia in 1919. In 1917, Dr. Lorenzo King was appointed chaplain of the Hanover Industrial Schools, one for boys and one for girls. It was his missionary work that established the school and the Hanover Welfare League. In 1918, the league bought an old building from nearby Courtland Farm. In 1925, the school moved to its present location in Frogtown on the old Washington Highway. The next year, it was opened as a school. (Hanover County Black Heritage Society.)

THE CLASS AT ELMONT. In 1981, Richard Saunders summarized the history of Elmont School: "Mr. Contee Robinson, who recently expired after his 100th birthday, had in 1915, envisioned a school to accommodate the growing colored school age population in the Elmont Area." The land and assistance came in the form of a land grant from Mr. H.E. Davenport. By 1916, the property was transferred to the Ashland School Board. (Hanover County Black Heritage Society.)

ELMONT SCHOOL. Elmont School burned in a fire exercise in 1990. Originally designed as many schoolhouses of its era, it was built of weatherboard. Sixteen feet wide, it had a standing seam metal roof. The main entrance was at one of the gable ends of the building, which had a plain door and no stoop or roof. (Hanover County Black Heritage Society.)

WICKHAM SCHOOL. Hanover County Black Heritage Society played a part in saving the Wickham School. Now the property of Providence Baptist Church, it had been slated to be torn down as part of the church's plan for a new sanctuary. (Hanover County Black Heritage Society.)

LINNEY'S CORNER. Throughout the 1880s and 1890s, there were nearly twice as many schools for white children as for African Americans. More striking still was the comparative number of white and black teachers. There were often only 3 to 5 teachers for as many as 15 black schools. By the 1930s, when Linney's Corner school (pictured here) was in service, schools were opened or closed for the year based on a certain enrollment of pupils. (Hanover County Black Heritage Society.)

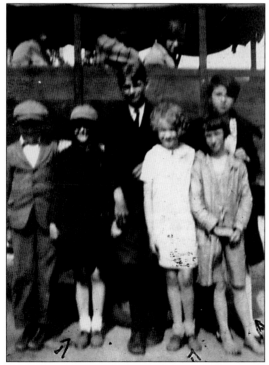

RIDING THE BUS. Children must have been delighted to have transportation to school, even if it was a horse-drawn wagon with canvas shades. From left to right are Maurice Moody, Lillian Moody, Bill Diehls, Rosalyn Moody, Eleanor Luck, and Oran Turner. Peeping out of the bus are Virginia Rose Moody, Ruth Trevillian, and Judith Hall around 1928.

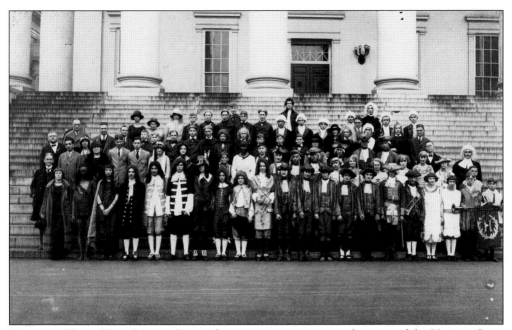

TAKING A FIELD TRIP. Montpelier students pose in costume on the steps of the Virginia State Capitol on a field trip in the 1920s. (Courtesy Barbara Jones.)

VINTAGE CLASSROOM. Today's schoolrooms bear little resemblance to the classrooms of the mid-1930s and 1940s. These trough windows did little to let in air and light. Central air conditioning was only a notion in the mind of a feverish student on a late June day. (*Herald-Progress.*)

MISS EDITH SAGLE'S MONTPELIER HIGH SCHOOL CLASS OF 1920. Pictured here from left to right are (first row) Elizabeth Moody, Lillian Pollard, Arline Childress, Muriel Stanley, Bradley Jones, and Hazel Waldrop; (second row) Gladden Harris, Eugene Meredith, Cecil Bowles, Broaddus Harvard, Hortense Buch, and Edith Harris; (third row) Amy Walters, Winnie Harris, Myrtle Stanley, Emma Terrell, Eugenia Beazley, and Polly Moore; (fourth row) Hattie Stanley, Jeanette Vaughan, Eldridge Stanley, Ela Isbel, Irma Hall, and Clara Rice. (Edith Sagle Jones.)

Seven

CHURCHES

BAPTISM IN THE MILLPOND. William M. Jones raises his hand to heaven and baptizes a young Alexander man in John W. Smith's millpond behind Gethsemane Church of Christ around 1912. Gethsemane was born from dissension. In 1832, Parson Charles Talley and several influential members of the Black Creek Baptist Church, including his son Ezekiel, left to form a Christian church called Bethesda near Cold Harbor where the parson ran a mill. This community, like so many, was nearly destroyed by the Civil War. The old church was burned in 1868 after having been struck by lightning. The new church was built in 1870, and the name changed from Bethesda to Gethsemane. The mill was purchased by the Smith family and run for many years. (Wesley Smith.)

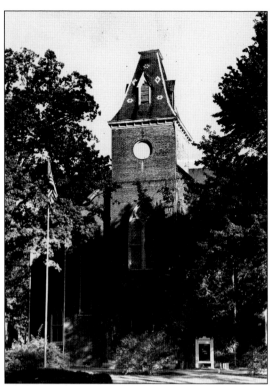

DUNCAN MEMORIAL CHAPEL. After the old ballroom chapel at Randolph-Macon burned in 1879, the college set about constructing a new house of worship. Duncan Memorial Methodist was built in 1879 and named after Dr. James A. Duncan, who had been president of the college from 1868 to 1877.

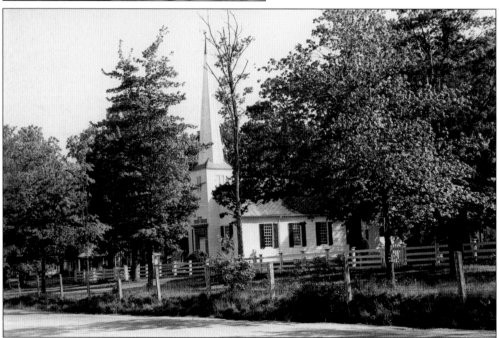

CHURCH OF OUR SAVIOUR. Church of Our Saviour was begun by Rev. Robert Nelson, who was born at Oakland in 1819. For most of his life, he was a missionary in China where he established the Chinese Church of Our Saviour in Shanghai, which provided some of the original building funds for the church in Montpelier. (*Herald-Progress.*)

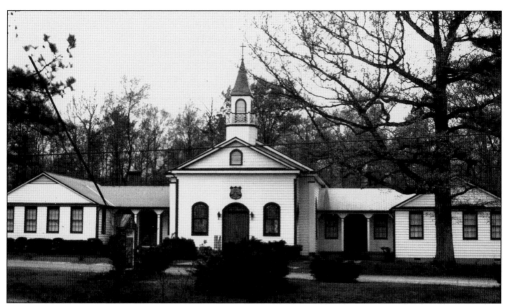

BLACK CREEK BAPTIST CHURCH. Black Creek Baptist Church was formed between 1775 and 1777. The Baptists seemed active dissenters in a push to obtain separation of church and state. This reform often caused rifts in congregations, and Black Creek saw many of its prominent members split to form Bethesda Church. (*Herald-Progress.*)

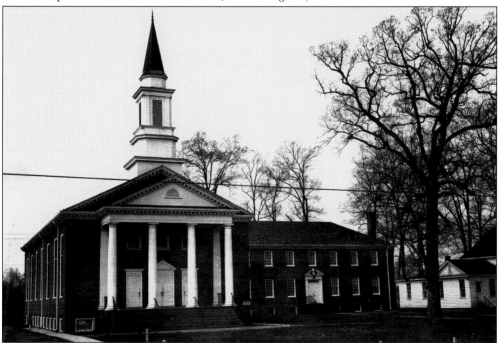

COOL SPRING BAPTIST. Cool Spring Baptist Church opened its doors in 1870. The most famous story associated with the church tells of a Sunday in 1905 when the church was struck by lightning immediately after the pastor had uttered the words "Christ will pilot you through the storm of life." Many people were hurt, some seriously, but no one was killed. Perhaps some believers were created that morning. (*Herald-Progress.*)

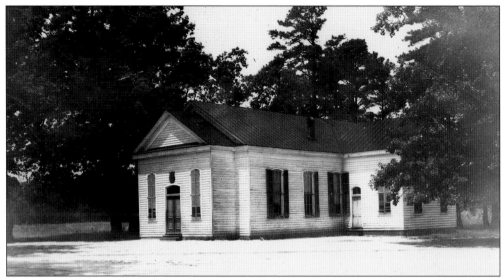

SHADY GROVE METHODIST CHURCH. Shady Grove Methodist Church was built in 1861 and was used as a Union hospital during the fighting around Mechanicsville. The building was torn down and rebuilt in 1881. (*Herald-Progress.*)

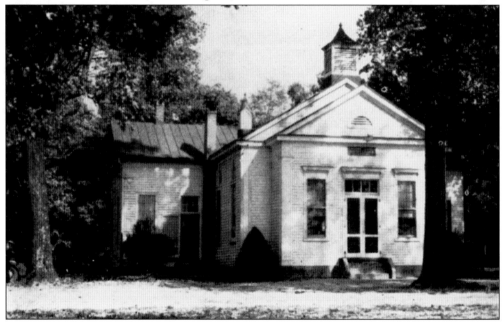

WALNUT GROVE. Walnut Grove was built in 1846 to house the 33 white and 430 black members of the congregation. Services were suspended when most of the white members entered the army in 1861. Nearby fighting at Mechanicsville, Ellerson's Mill, Bethesda Church, Gaines' Mill, and Cold Harbor devastated local farms and created refugees of the local population. After the war, an entry in the church records states: "The colored members expressed a desire to dissolve their formal connection with this church. . . . They are herby [*sic*] dismissed. . . . They are invited to occupy the gallery as heretofore whenever we hold worship in this house, and that they be allowed to use this house until they can erect a meeting house for themselves." (*Herald-Progress.*)

SLASH CHURCH. The historical marker tells the story of Slash Church: "Erected in 1729 . . . Slash Church's location next to swampy woods (a 'slash' in 18th-century terms) gave it its name. The Reverend Patrick Henry, uncle of the famous patriot, served as rector from 1737 until 1777. Among its early worshipers the church claims Patrick Henry, Dolley Madison, and Henry Clay, all once residents of the area. During the Civil War, Slash Church was used as a hospital and gave a nearby cavalry battle its name. This white weatherboarded structure survives as the oldest and best-preserved frame colonial church in Virginia, and the only one to escape enlargement."(*Herald-Progress.*)

MOUNT OLIVET BAPTIST. Mount Olivet Baptist was formally organized in 1847. Before slavery was abolished in 1865, blacks and whites worshiped together. On December 3, 1865, the congregation resolved "that the colored members numbering about two hundred be dismissed from that church and discharged from all obligations to the church as members thereof, and left free to act for themselves." (*Herald-Progress.*)

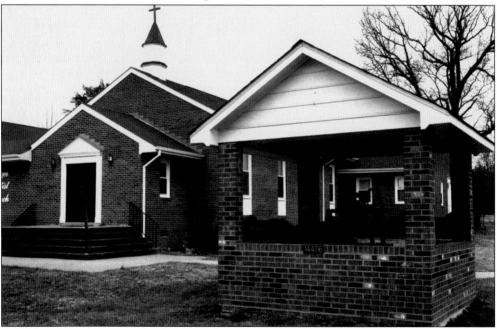

EBENEZER CHURCH. Ebenezer Church was founded in 1866, when the African-American members of Mount Olivet split from that church to organize their own. In 1912, the present Ebenezer Baptist Church was built. In 1922, a public school was built on the property. (*Herald-Progress.*)

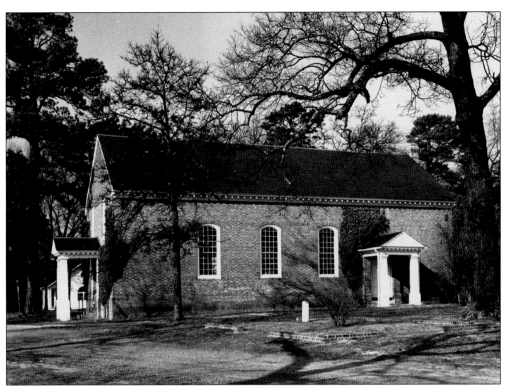

FORK CHURCH. Fork Church was built in around 1735 atop the foundations of an earlier building, called the Chapel-of-Ease and dating to around 1722. Fork Church's architectural significance is well documented. Its cemetery holds generations of Nelsons, Pages, Meades, and Aldridges, among many others. The church organ, originally pumped by hand, has been electrified and restored. Made by a German Catholic named Berger, it is one of only two still in existence. (*Herald-Progress.*)

IMMANUEL CHURCH. Immanuel Church's present brick structure was erected in 1853, but the church's history goes back as far as the late 1600s. A church built in 1690 was replaced by another around 1718 at the crossroads village, which was later to take its name from the "old church" there. (*Herald-Progress.*)

CALVARY EPISCOPAL. Calvary Episcopal Church began as a Sunday school organized in 1917 by Rev. Alonzo King. King was then in charge of religious work at the Hanover Industrial School for boys. (*Herald-Progress.*)

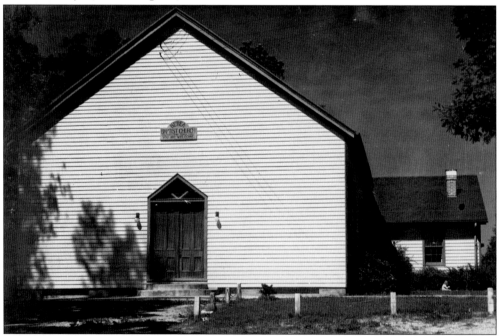

BEREA BAPTIST CHURCH. Formed in 1846, Berea Baptist Church was built in 1848. Early records show that members could be excluded for some of the following offenses: drinking or selling liquor, stealing, turning traitor, holding opinions contrary to the church's faith, dancing and singing comic songs, disagreements, and fighting. (*Herald-Progress.*)

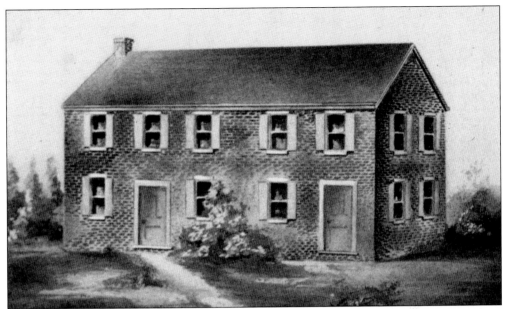

CEDAR CREEK MEETING HOUSE. Cedar Creek Meeting House of the Society of Friends in Montpelier served the Quaker population for over 200 years beginning in the 1730s. It was at the meeting house that a rule was voted to abolish slavery in Virginia, possibly the first such vote in the state and perhaps in the South. (*Herald-Progress.*)

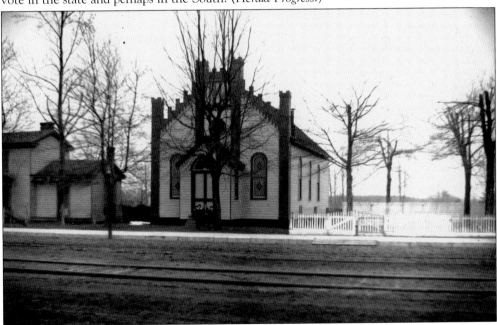

ST. JAMES THE LESS. This is the original church built in 1878 on what is today Center Street in Ashland. Julia Weisiger, town operator and church historian, wrote that "the vestry men could not agree, some wanting the church on a back street where the trains could not be heard. . . . Others wanted it on the front . . . because the railroad track was the only possible walk in bad weather." The church was demolished in 1958, and the congregation moved to a larger facility on Beverly Road. (Woody and Susan Tucker.)

113

POLEGREEN. Built in 1748, Polegreen Church is named after a local landowner. The oratory of Samuel Davies, who often preached here, revolutionized the focus of religious thought in the colonies. Patrick Henry, who lived nearby, attended church as a young man. During the Civil War, the church stood between enemy lines, and on June 1, 1864, Confederate cannons set the church ablaze. It burned to the ground never to be rebuilt. Dr. Robert Bluford Jr. is responsible for organizing efforts to built this memorial designed by Careton Abbott. (Dale Talley.)

Eight

ASHLAND AND
RANDOLPH-MACON

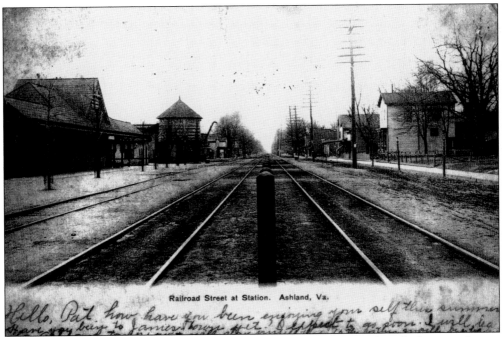

A TRAIN RUNS THROUGH IT. Railroad Street in Ashland is shown here looking south as it appeared in the early 1900s. Ashland was incorporated in 1858. It changed its name from Slash Cottage to Ashland (after Henry Clay's Kentucky home) sometime in the 1880s. The town was developed by the Richmond, Fredericksburg and Potomac Railroad, and its location near the railroad was instrumental in drawing Randolph-Macon to re-establish itself there in 1867. (Woody and Susan Tucker.)

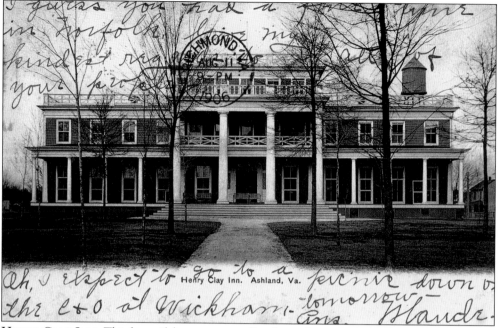

HENRY CLAY INN. This beautiful testament to Southern charm was razed by fire in the 1940s. It has been rebuilt as a replica of the original. The wide porches complete with rocking chairs speak to a quieter time. (Woody and Susan Tucker.)

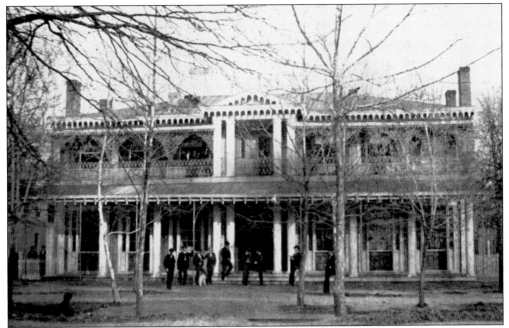

ASHLAND HOTEL AND MINERAL WELL COMPANY. Originally called Slash Cottage, the facility was built by the railroad as a resort. It was sold to the college in 1868, and students used the upper floors and outer cottages as dormitories. The ballroom downstairs often served as a chapel. With no central heat or running water (meaning no indoor bathrooms), the facility actually facilitated the growth of boarding houses in the town. (*Herald-Progress.*)

GASLIGHTS. Dorothy Jones tells of the lamplighter in Ashland who filled the gaslights with just enough fuel until the next time he came around in order to make his burden lighter. This old photograph, resurrected from an antique store by Woody Tucker, is one of the few extant showing the romantic old lamps. (Woody and Susan Tucker.)

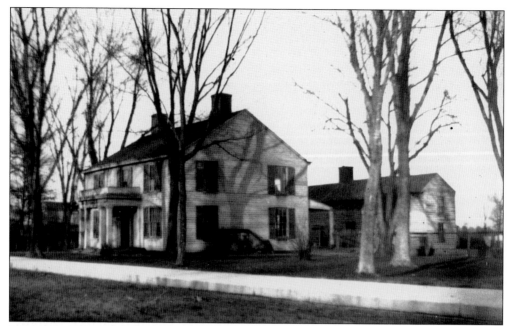

MACMURDO HOME. Still standing on Center Street and looking much as it did in 1857, this was the home of C.W. Macmurdo, the treasurer of the Richmond, Fredericksburg and Potomac Railroad. The family raised nine children in this home and lived there until the 1950s. (Woody and Susan Tucker.)

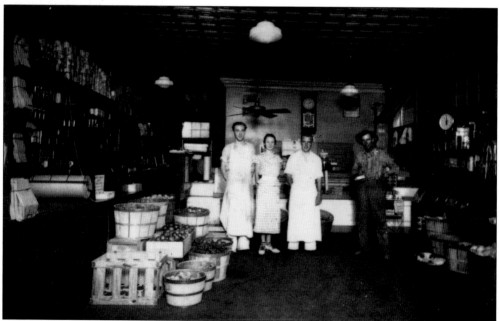

CROSS BROTHERS STORE. Established around 1912, the business is still in the same family after 92 years. Stepping inside the store in Central Ashland is like stepping back in time. In the early days, groceries might be delivered (on account) by horse and buggy. One resident remembers that "if they didn't have it at Cross Brothers, I didn't need it." The tradition of community service is still a large part of this anchor of Ashland commerce. (Tom Willis.)

HUGHES DRUG STORE. The drug store has always seemed a part of Ashland. If you look up as you walk south on Center Street, you can see the name still displayed at the top of the building. At one point, it served at the town hall when rooms were rented upstairs. Anne Curtis Palmore remembers everyone gathering for Cherry Cokes in paper cups in aluminum stands at the booths inside. (*Herald-Progress.*)

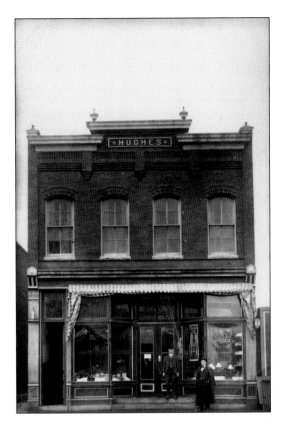

GO TO...

HUGHES DRUG STORE

FOR

DRUGS
COLLEGE TEXT BOOKS

FINE Stationery
AND COLLEGE SUPPLIES

Students' Lamps, Chimneys, Oil, Etc.

STUDENT ONE STOP SHOPPING. This ad for Hughes Drug appeared in a turn-of-the-century Randolph-Macon student publication. (Randolph-Macon Archives.)

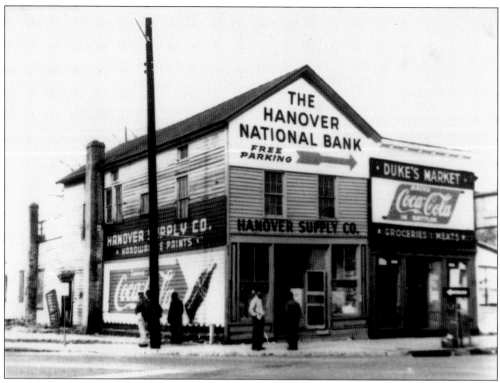

THE COUNTY'S FIRST BANK. Here, a sign points to the location of the Hanover National Bank established in 1903. The first building was slightly north of the old post office. (Tom Willis.)

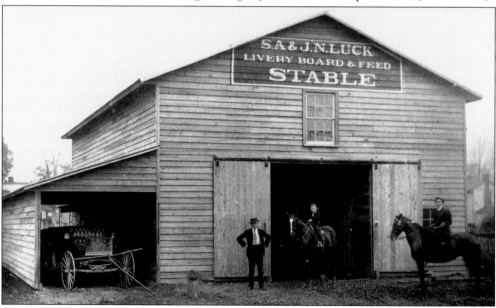

LIVERY STABLE TO CAR DEALERSHIP. James Napoleon "Jimmy" Luck and his brother Samuel Apollos began a livery stable in Ashland perhaps as early as 1908. Around 1915, Jimmy Luck bought the Hanover garage from R.L. Brillhart, F.W. Tucker, Boxley Vaughan, and L.L. Foy. Here, he established one of the oldest Chevrolet dealerships on the East Coast. (Ron Luck.)

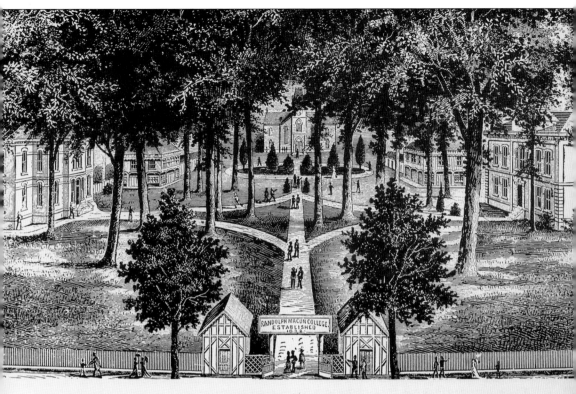

Randolph Macon College - 1880

RANDOLPH-MACON COLLEGE. This woodcut is an illustration of the campus in 1880. Chartered by the General Assembly of Virginia in February of 1830, Randolph-Macon is the oldest Methodist college in America. The depression following the Civil War was one of the leading factors in the college's move in 1868 from its original home in Mecklenburg County to the resort village of Ashland, where the train provided easier access to more students who could provide revenue to the college. The college brought a new vitality to Ashland, which saw local merchants, restaurants, and boarding houses flourish from the infusion of cash from the student body. (Randolph-Macon Archives.)

THE YEAR BOOK. Bound in cloth and glowing with the colors of the college (yellow and black), *The Yellow Jacket* from 1900 chronicles the class of that year. For the entire term of 1900, the college enrolled 127 undergraduates and 5 post-graduates. Today, the enrollment is ten times that number. (Randolph-Macon Archives.)

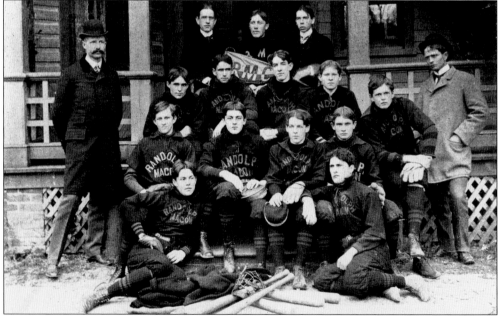

THE 1900 BASEBALL TEAM. The college had teams for football, baseball, gymnastics, and tennis. The players went up against school rivals. In 1900, officials from Randolph-Macon, Richmond College, Hampden-Sydney College, Virginia Military Institute, Washington and Lee University, Virginia Polytechnic Institute, and the University of Virginia met at UVA to form the Virginia Intercollegiate League. (Randolph-Macon Archives.)

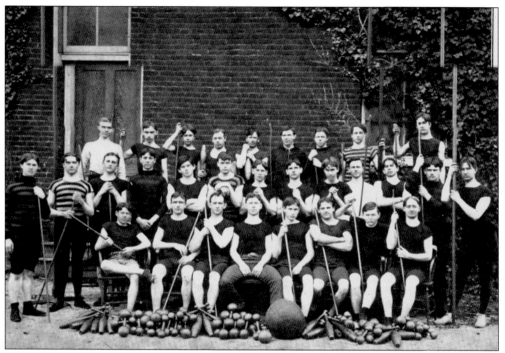

ATHLETIC CLUB. Without the elaborate equipment of today's gymnastics teams, this 1901 Athletic Club honed their skills with medicine balls and Indian clubs. (Randolph-Macon Archives.)

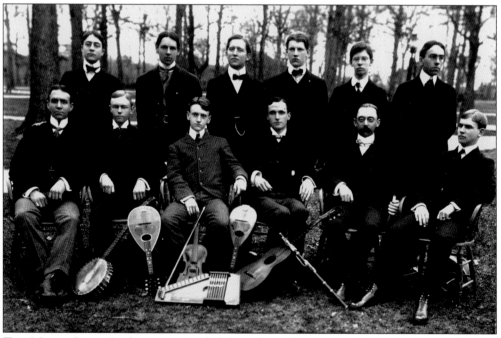

THE MUSIC CLUB. Students organized clubs to have the opportunity to associate with those who shared the same interests and to demonstrate their talents. Here is the Music Club sometime in the early 1900s. (Randolph-Macon Archives.)

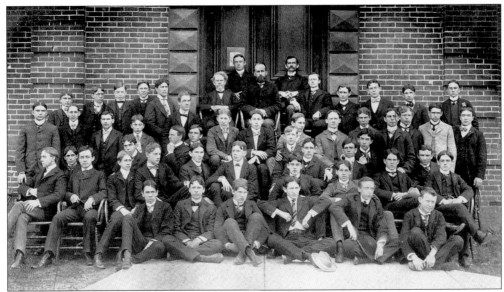

LITERARY SOCIETY. The Franklin and Washington Literary Societies were powerful campus organizations. Tired of boarding houses and cramped facilities in the old Slash Cottage, they set out to build their own meeting rooms and libraries. Although funding was difficult, Washington and Franklin Hall was completed in 1872. It was the first brick building in Ashland and the first permanent structure to be identified with Randolph-Macon College. The Franklin Society is pictured above in early 1900. Below is the Washington Society in 1900. (Randolph-Macon Archives.)

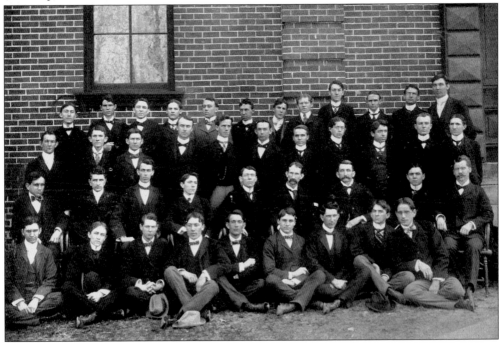

GRAFFITI GYM. Pace Gymnasium was built in 1887 when J.B. Pace donated $3,000. The building has also been a post office, a hall for the Commons Club, and an artist's studio where John Temple Witt modeled the statue of "Bojangles" Robinson, the famous African-American dancer from Richmond. The gym was used as a Yellow Jackets' scoreboard before it was torn down in 1974. (*Herald-Progress.*)

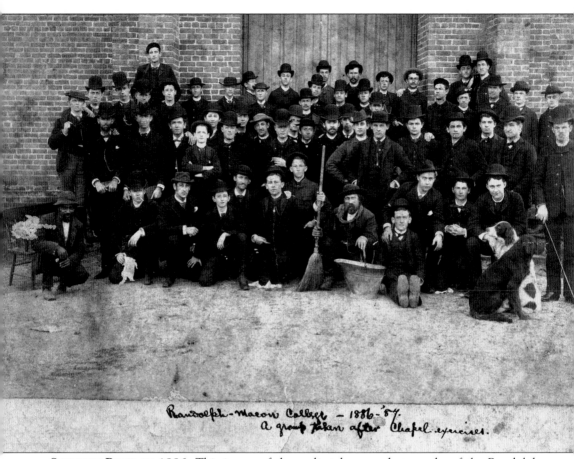

Randolph-Macon College – 1886-'87.
A group taken after Chapel exercises.

STUDENT BODY IN 1886. This is one of the earliest known photographs of the Randolph-Macon student body. It was taken after chapel services when they had all assembled. (Randolph-Macon Archives.)

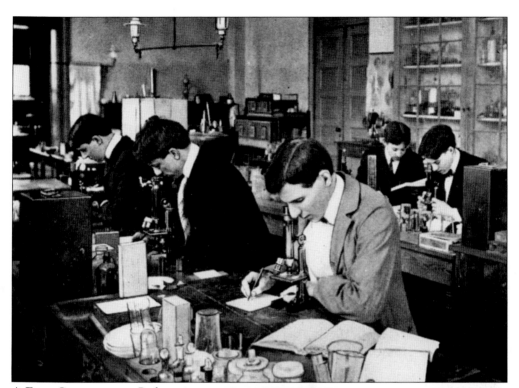

A Full Curriculum. Perhaps it was in a lab like this that J.W. Lambert—Randolph-Macon student, president of the literary society, and the inventor of Listerine—concocted his formula. (Randolph-Macon Archives.)

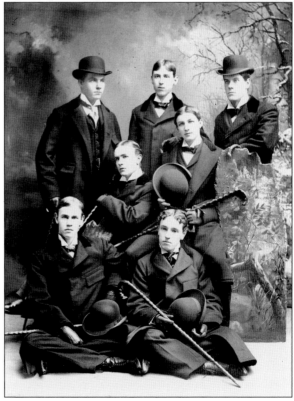

Fraternity Life. From 1895–1896 comes this photograph of the members of the Gamma Gamma chapter of Sigma Chi fraternity. Shown here from left to right are (front row) Henry A. Christian and Albert H. Licklider; (middle row) A.C. Southhall and P.H. Drewry; (back row) W.S. Denna, James Muller, and S.H. Watts. (Randolph-Macon Archives.)

BIBLIOGRAPHY

Aaroe, Alden. Hanover Historical Commission, Interviews by Alden Aaroe, 1992.

Fisher, David Hackett. *Albion's Seed*. Madison, NY: Oxford University Press, 1989.

Foote, Shelby. *The Civil War*. 3 vols. New York: Random House, 1958.

Govan, Gilbert E. and James W. Livingood. *A Different Valor: The Story of General Joseph E. Johnston*. New York: Bobbs Merrill, 1956.

The Hanover County Black Heritage Society. *One and Two Room Schools*. Hanover, VA: Virginia Foundation for the Humanities and Public Policy.

Hanover County Historical Society. *Hanover County, Virginia: A Retrospective, 1993*. Hanover, VA: Wadsworth, 1993.

————. *Hanover County Historical Society Bulletin, Volume I: 1969–1987*. Hanover, VA: Wadsworth, 1987.

————. *Old Homes of Hanover County, Virginia*. Summersville, WV: 1983.

Hassler, William W. *A.P. Hill: Lee's Forgotten General*. Richmond: Garrett-Massie, 1957.

Herald-Progress. 1881–1971 Commemorative Historical Edition. Ashland: *Herald-Progress*, 1971.

Lancaster, Robert Bolling. *A Sketch of Early History of Hanover County*. Ashland, VA: *Herald-Progress*, 1957.

Manarin, Louis H. *15th Virginia Infantry*. Lynchburg, VA: H.E. Howard, Inc., 1990.

McKenney, Carlton Norris. *Rails in Richmond*. Glendale, CA: Interurban Press, 1986.

Page, Rosewell. *Hanover County: Its History and Legends*. Salem, MA: Higginson Book Company, 1926.

Scanlon, James Edward. *The History of Randolph-Macon College*. Charlottesville, VA: University of Virginia Press, 1983.

Shalf, Roseanne Groat. *Ashland, Ashland, The Story of a Turn-of-the-Century Railroad Town*. Lawrenceville, VA: Brunswick Publishing Company, 1994.

Smith, Wesley. *Eastern Hanover Classic Album*. Richmond, VA: James F. Smith & Sons, 2002.